Lolita Fashion
Coloring Book for Adults

Illustrations by
Glenn Song

Copyright ©2015-2016 by Glenn Song

All rights reserved.

ISBN: 978-1539470090

First Edition

Printed by CreateSpace, An Amazon.com Company

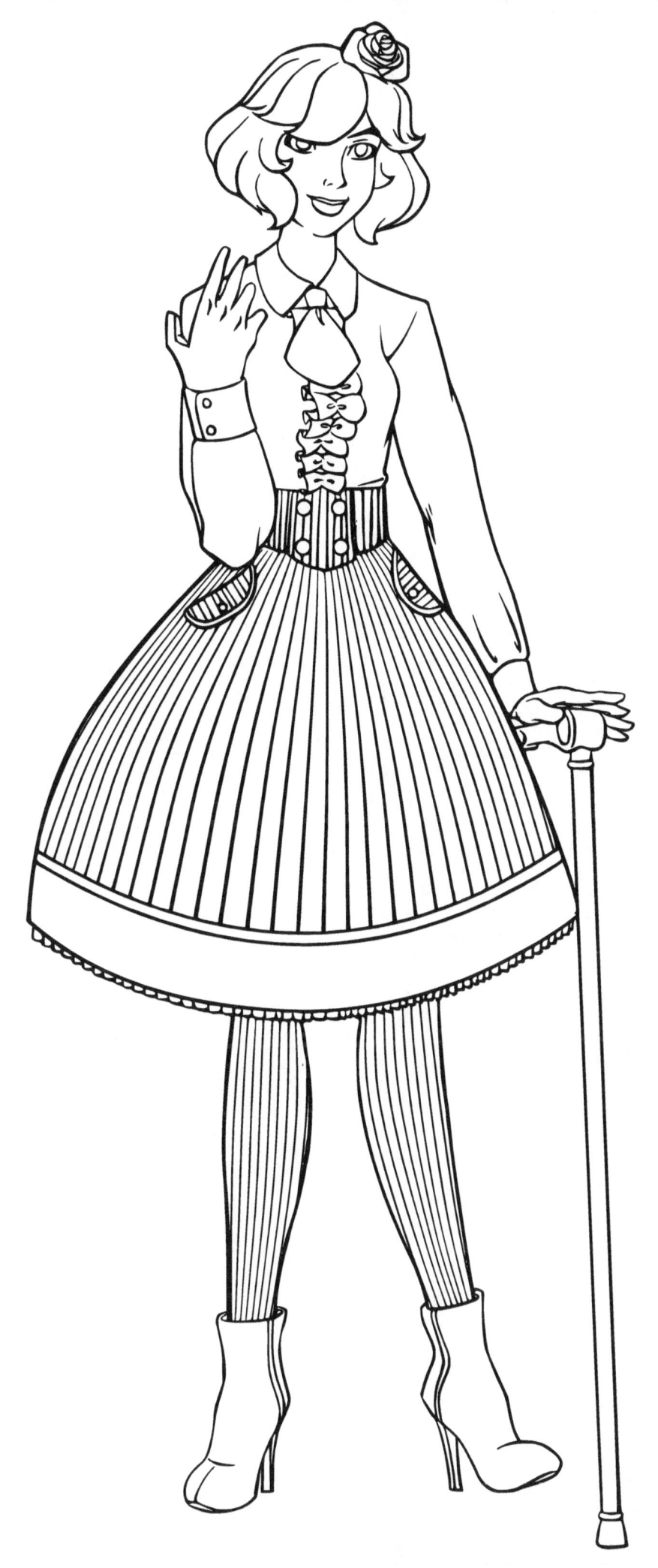

#1 "Dear Kamiko"

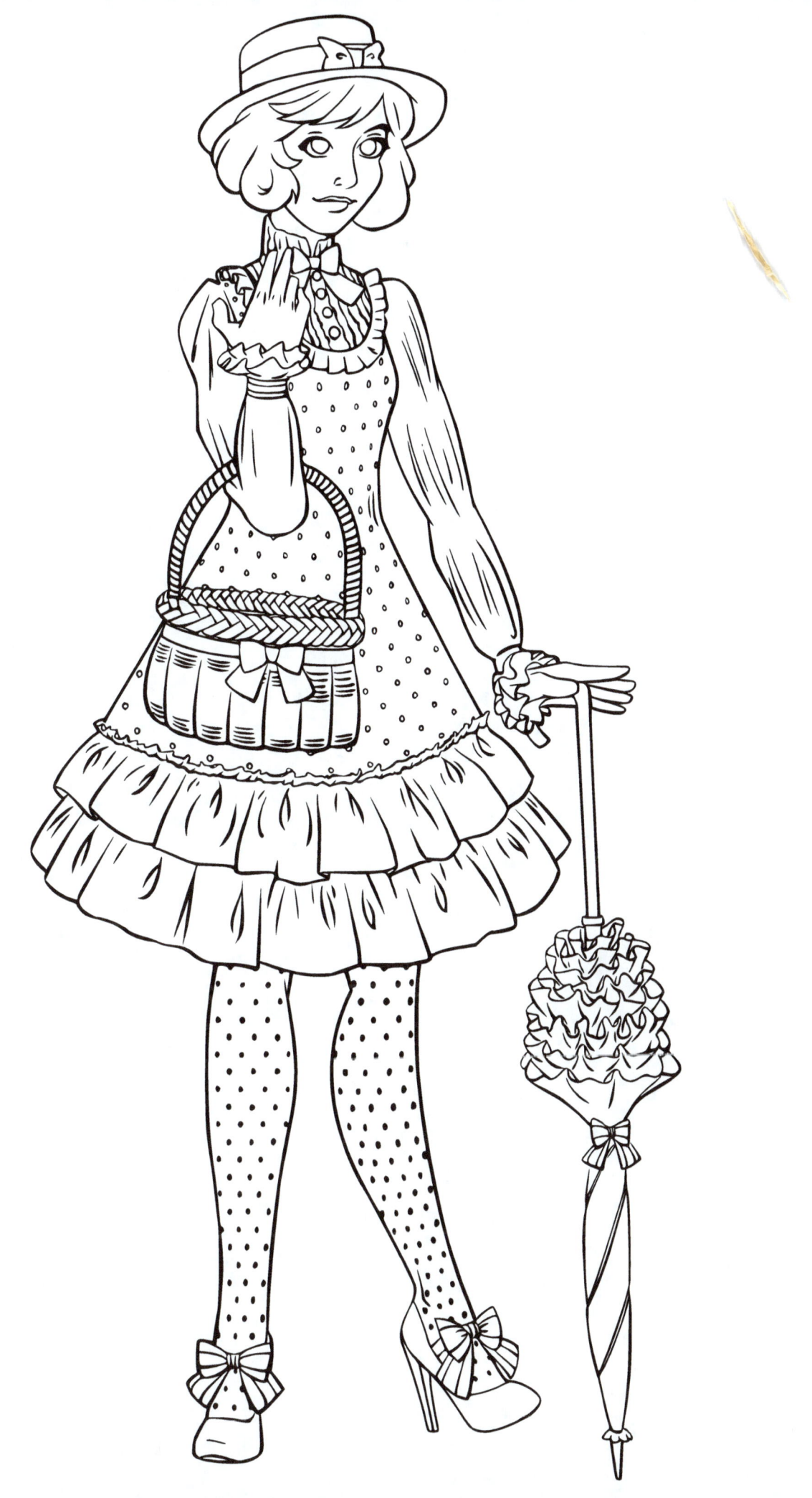

#2 "Country Lolita"

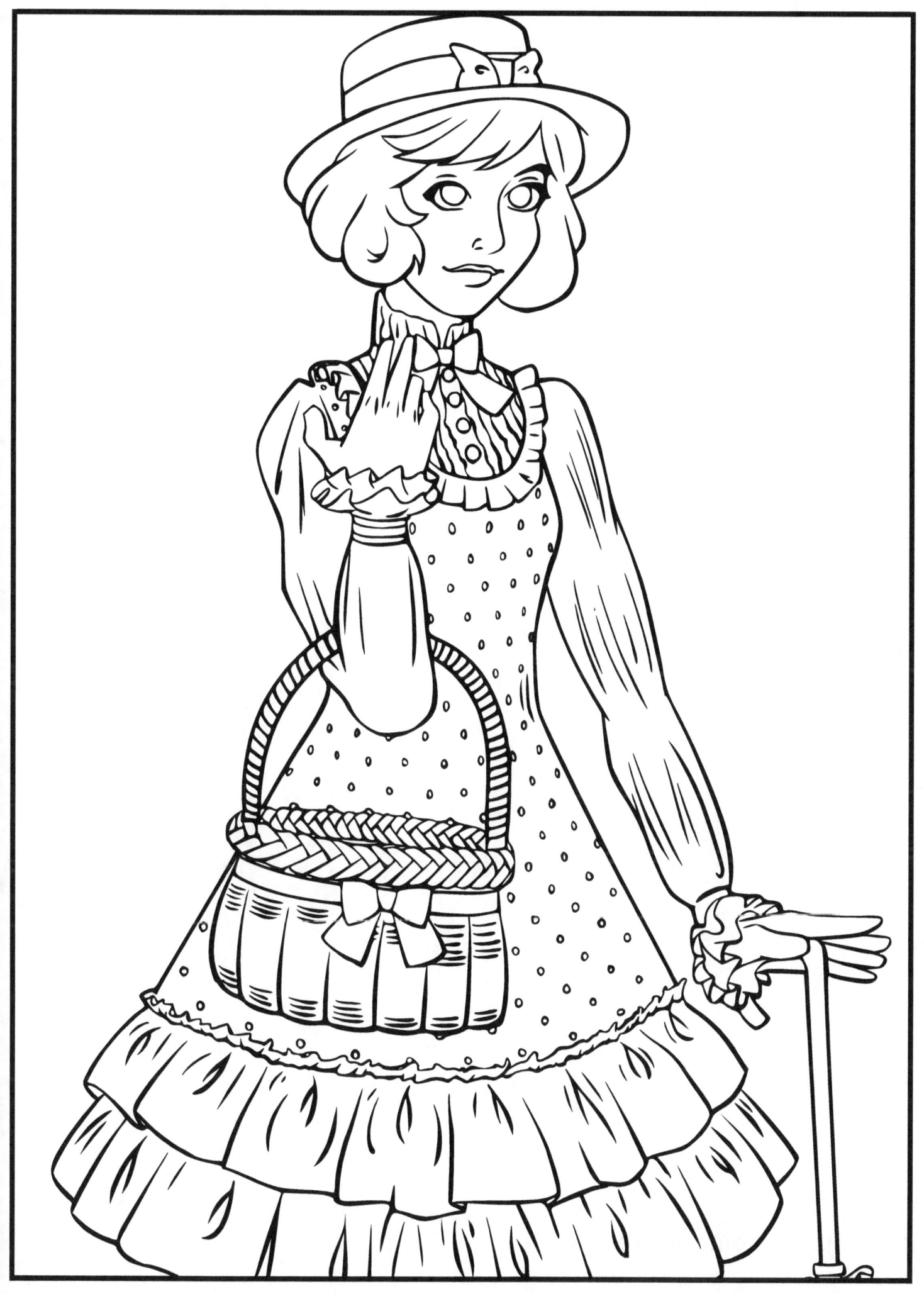

#2 "Country Lolita" (close-up)

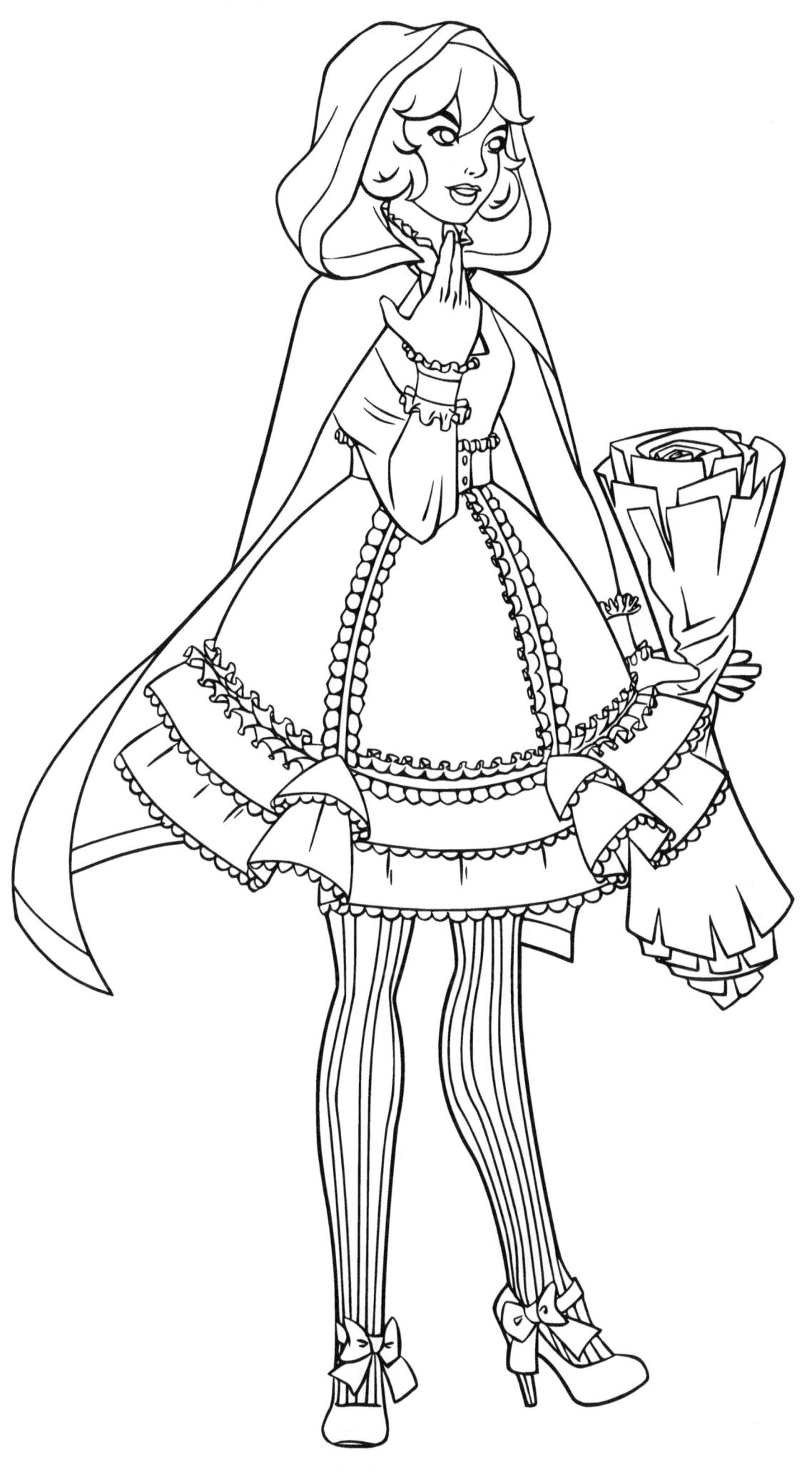

#3 "The Ferrygirl"

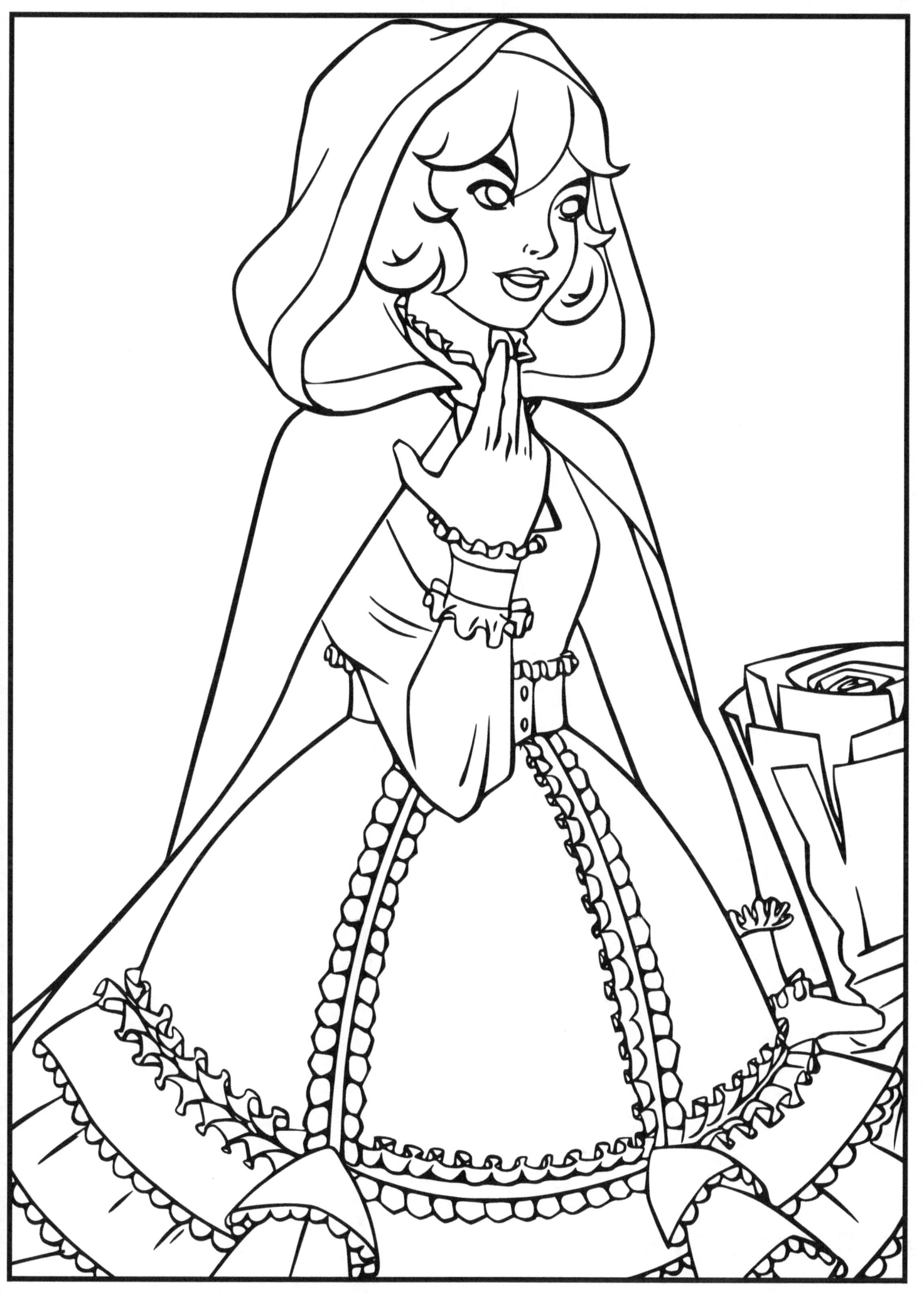

#3 "The Ferrygirl" (close-up)

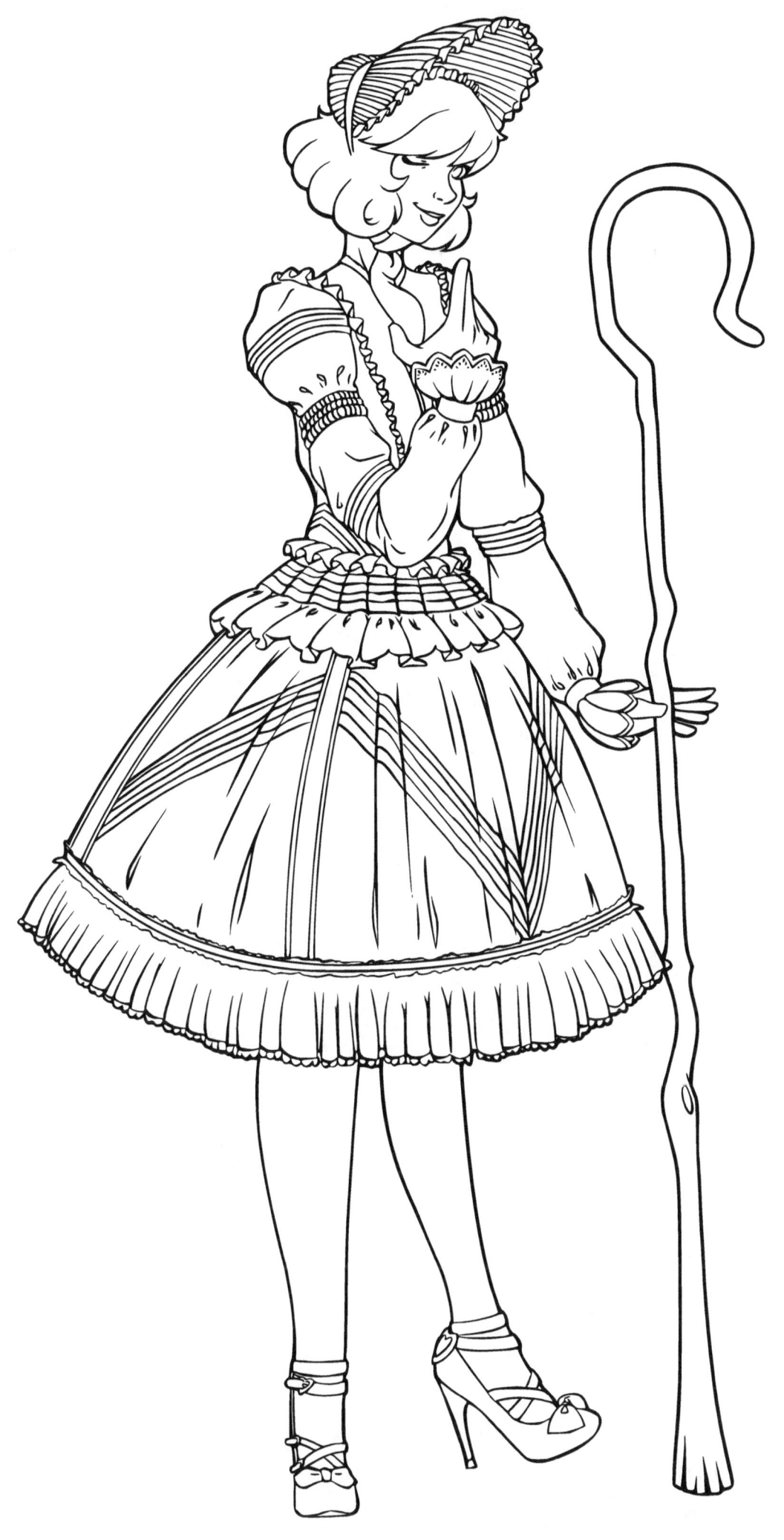

#4 "The Shepherd"

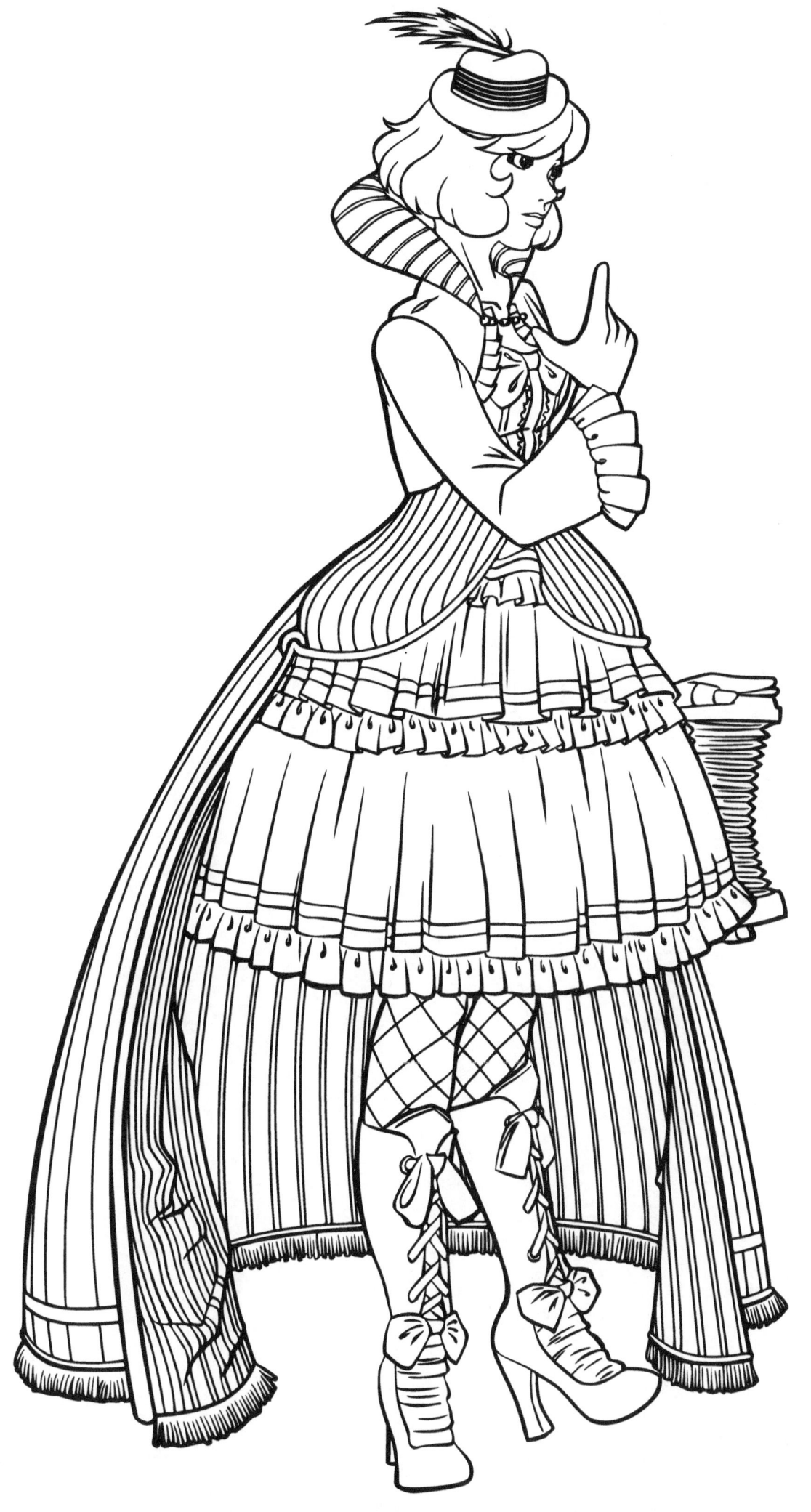

#5 "The Queen"

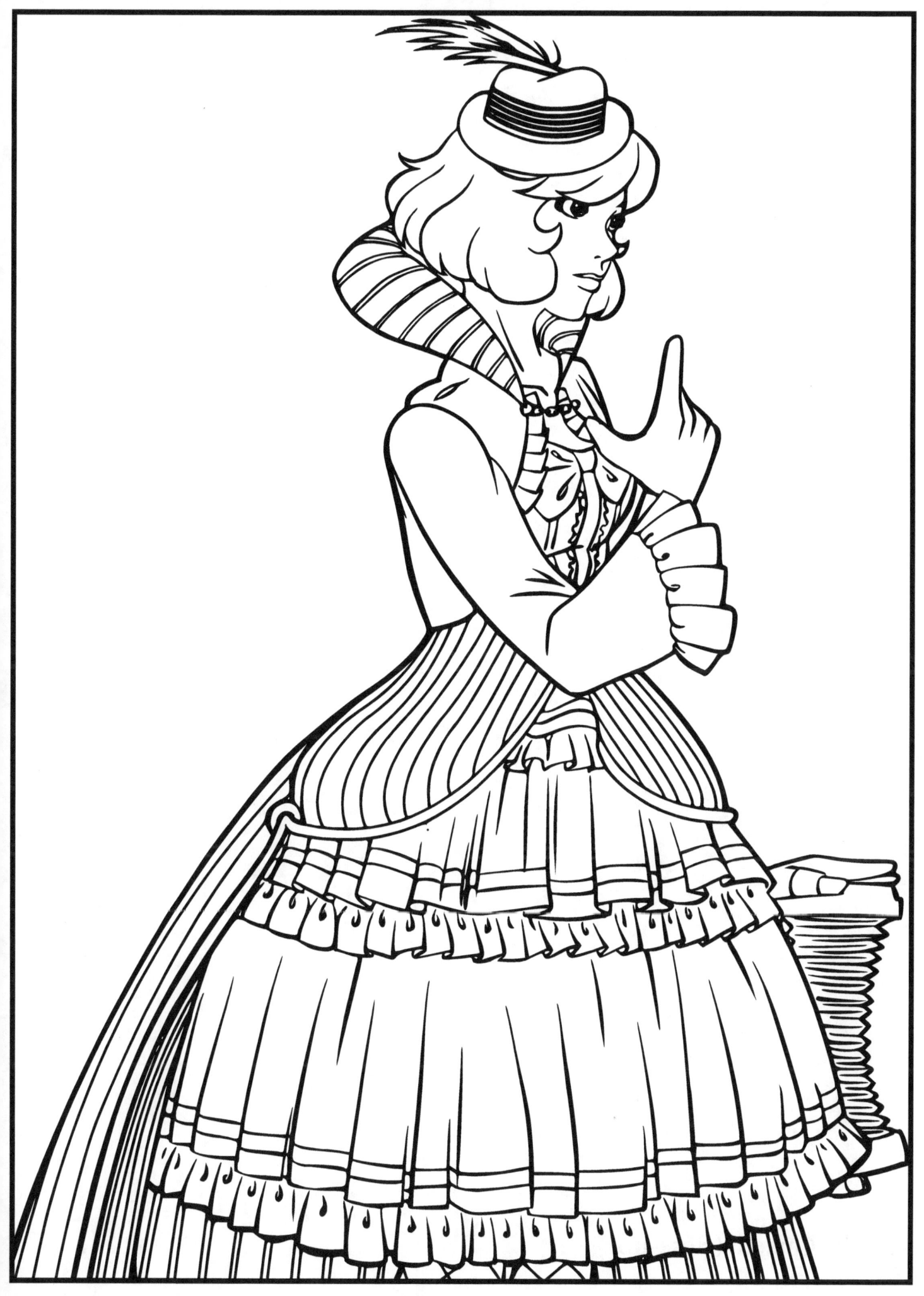

#5 "The Queen" (close-up)

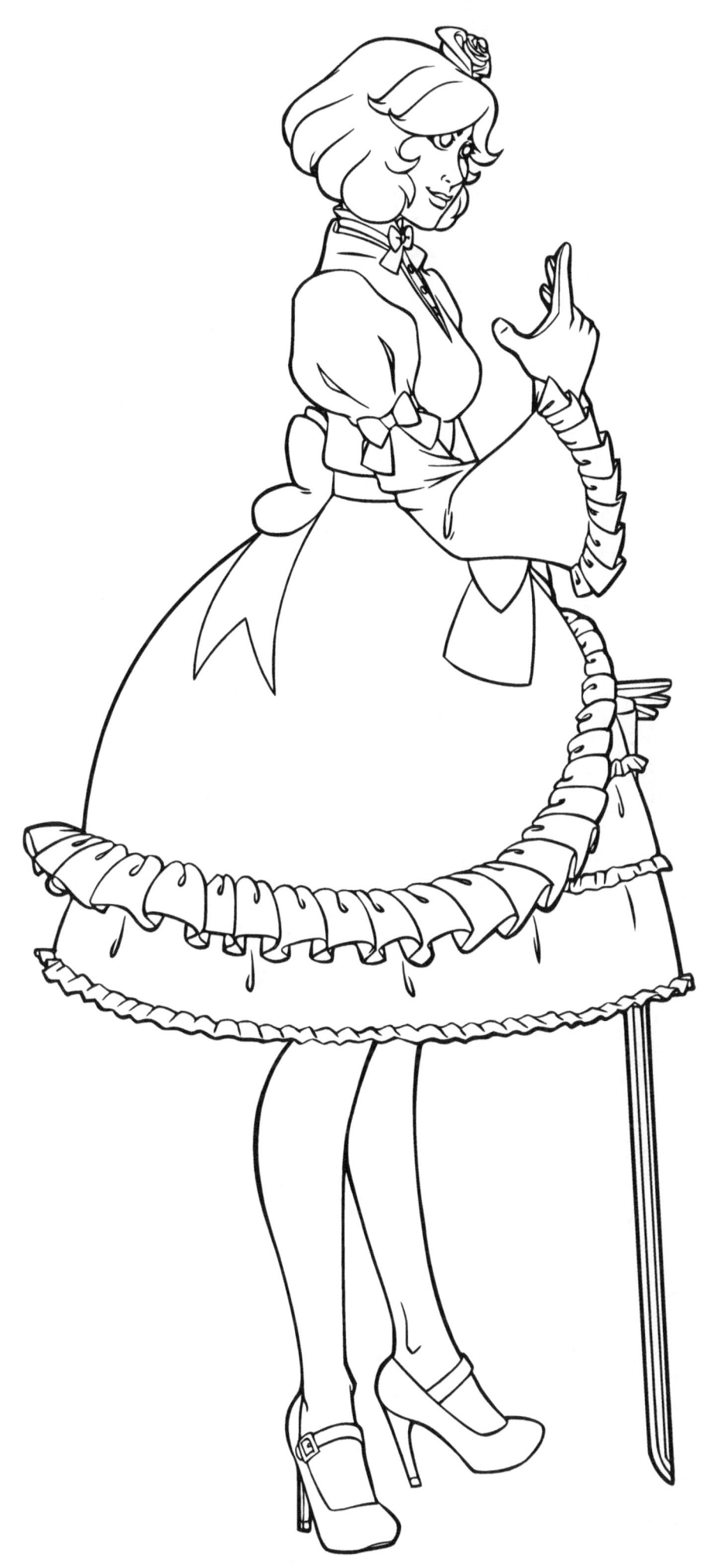

#6 "The Rabbit and the Moon"

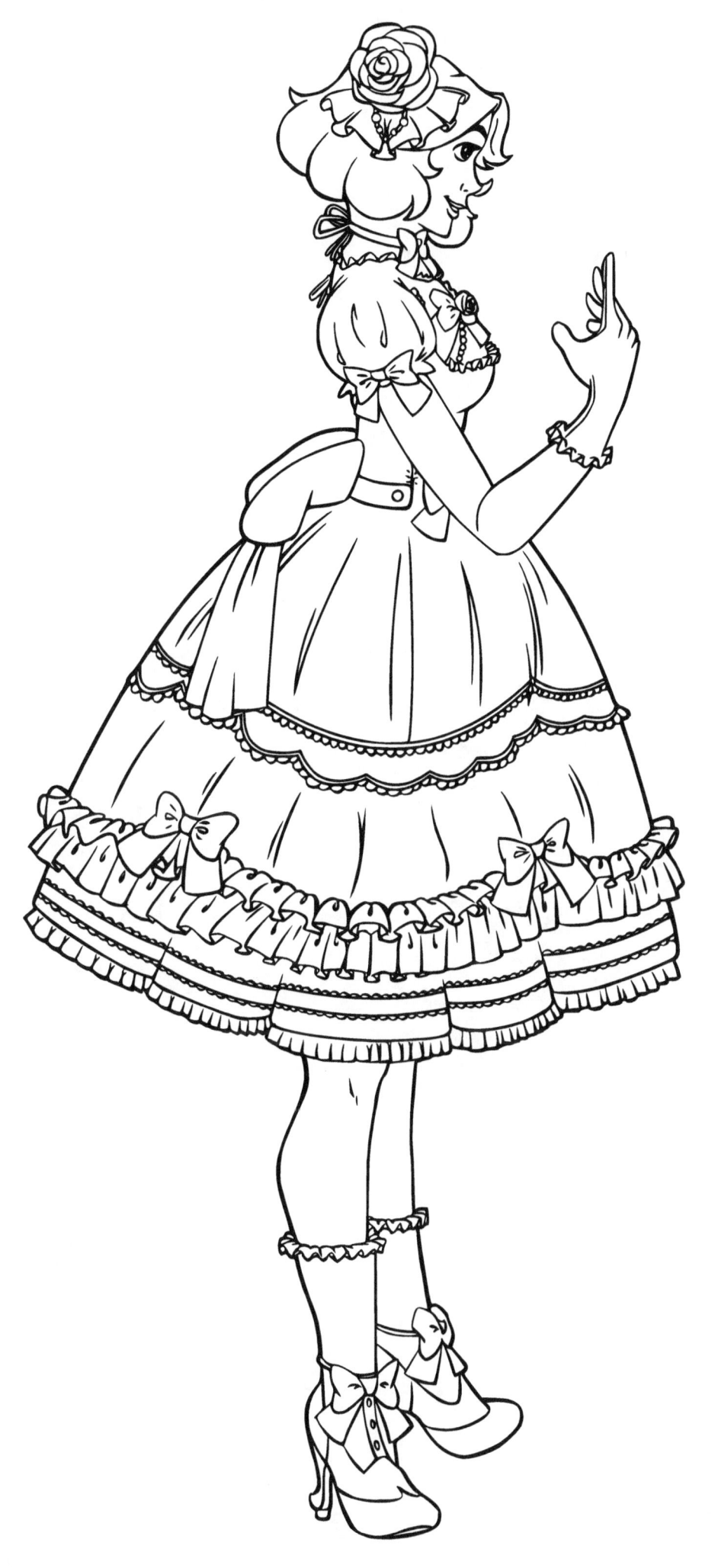

#7 "Pretty Angel"

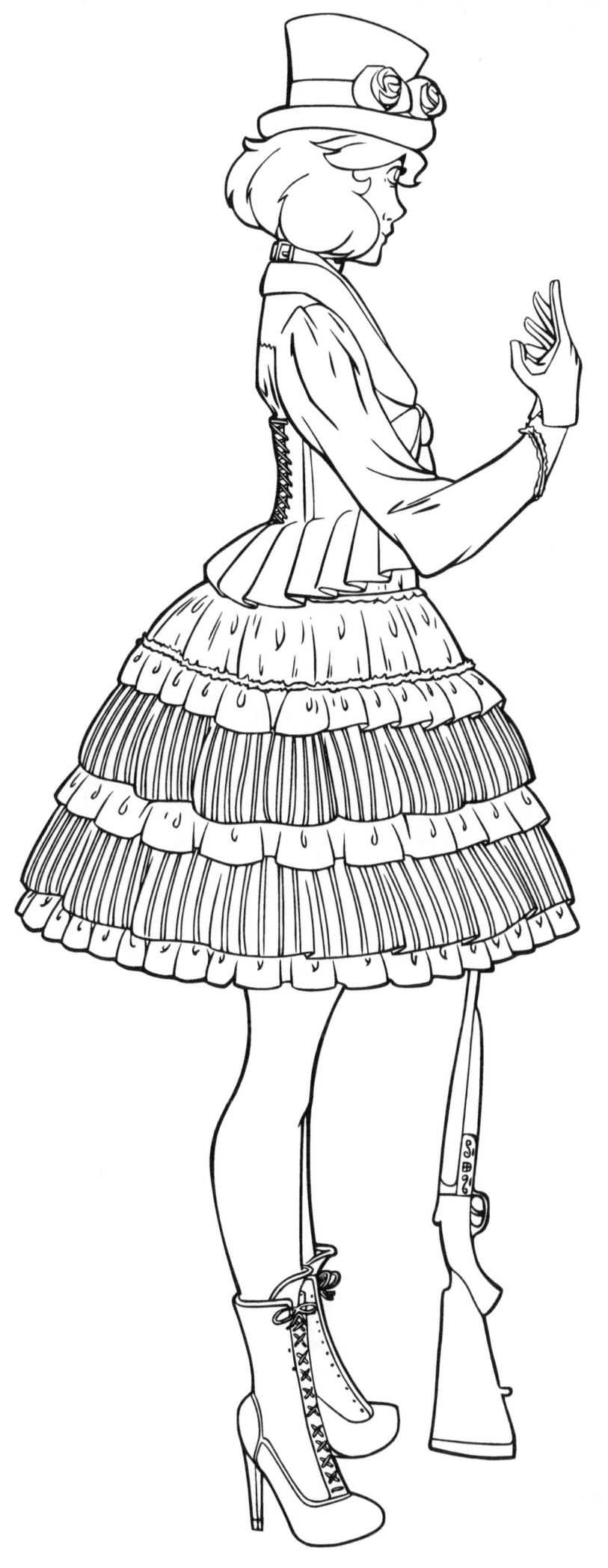

#8 "The Aristocrat"

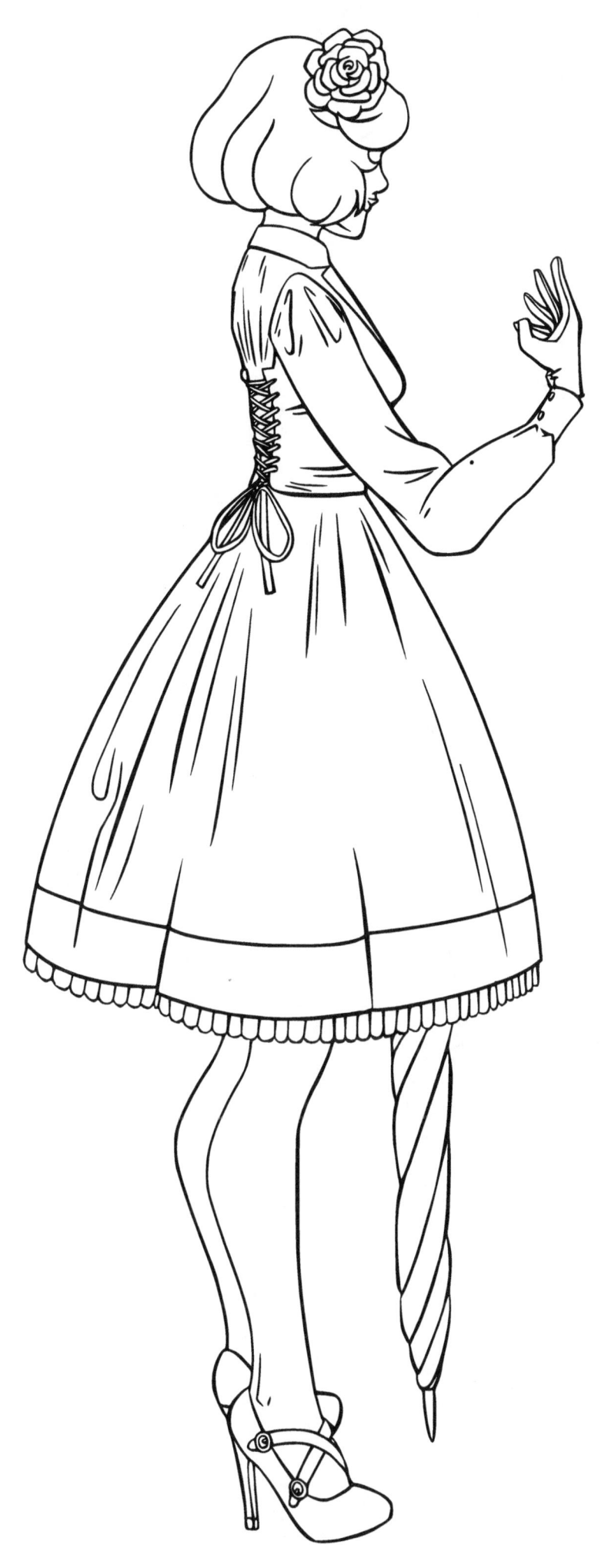

#9 "Miss Point"

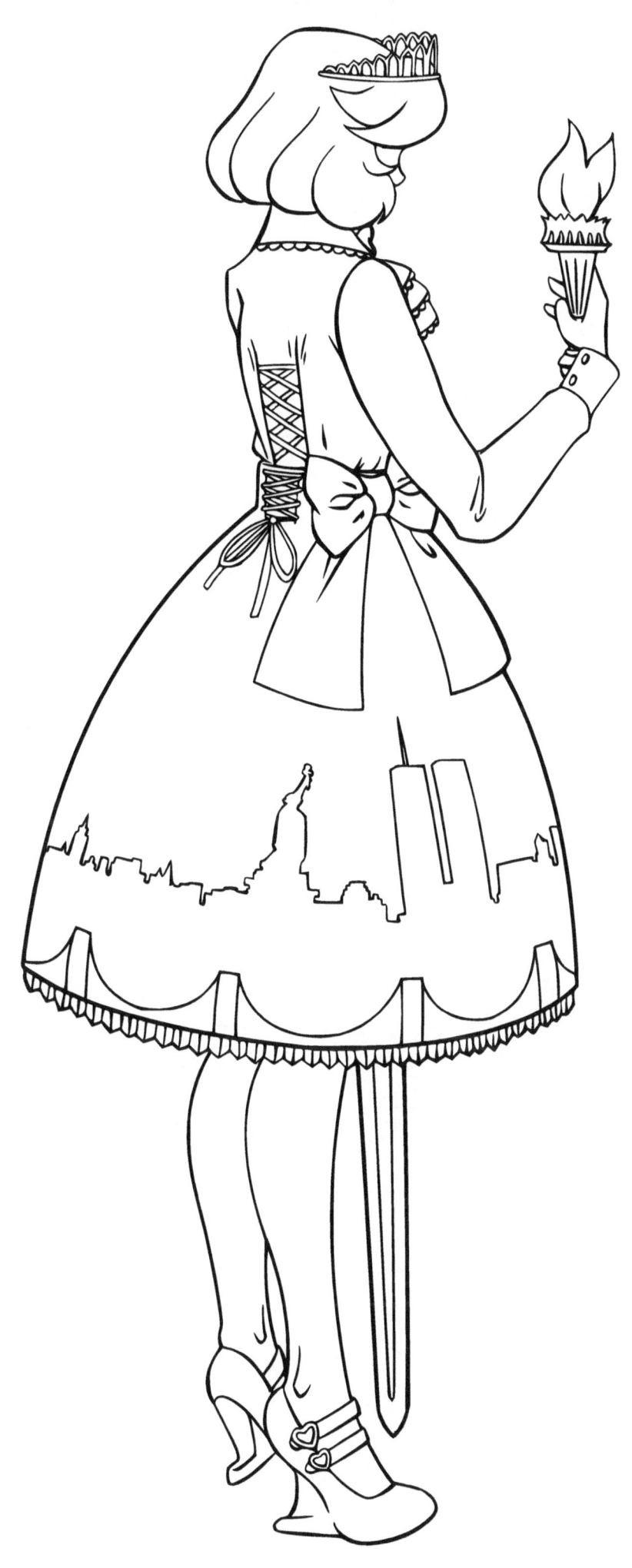

#10 "Lady Liberty"

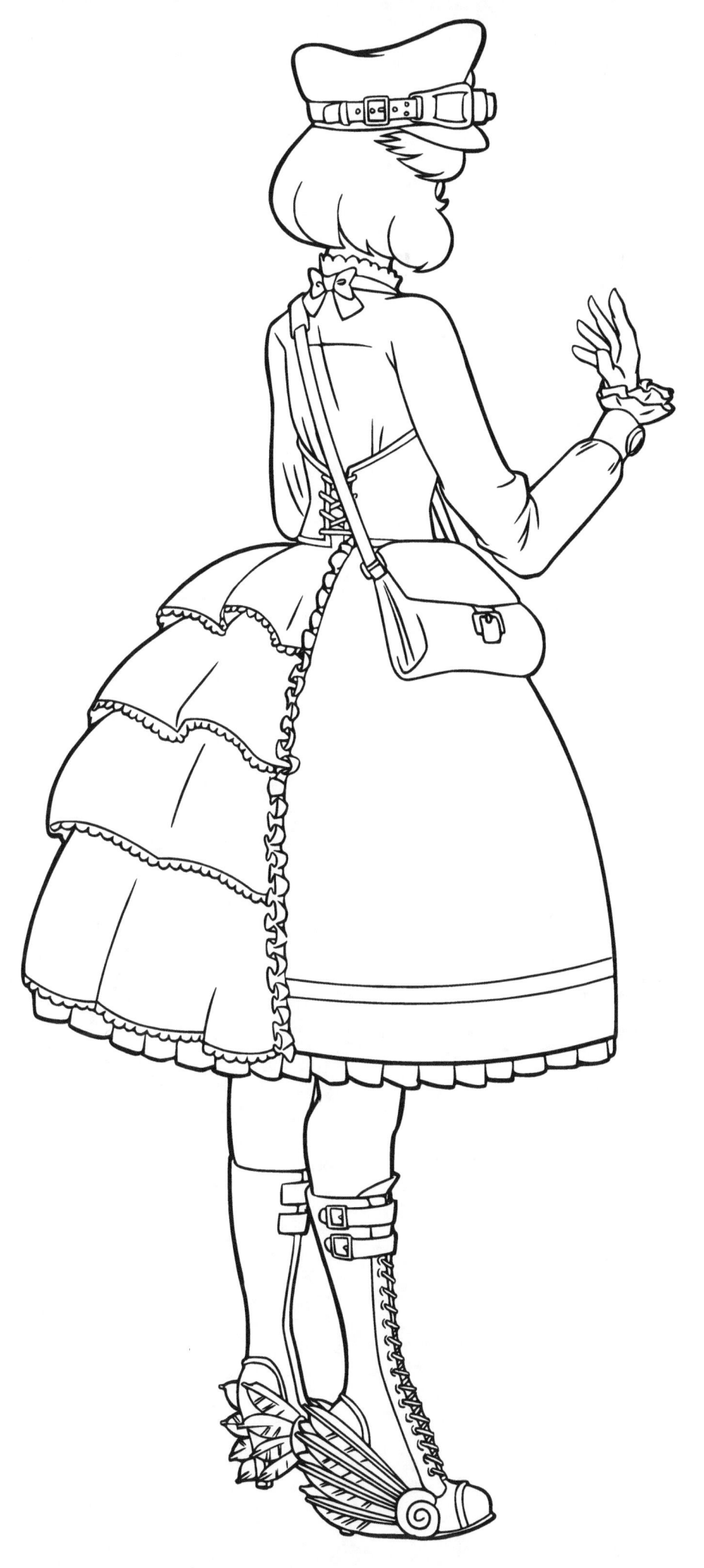

#11 "Hermes"

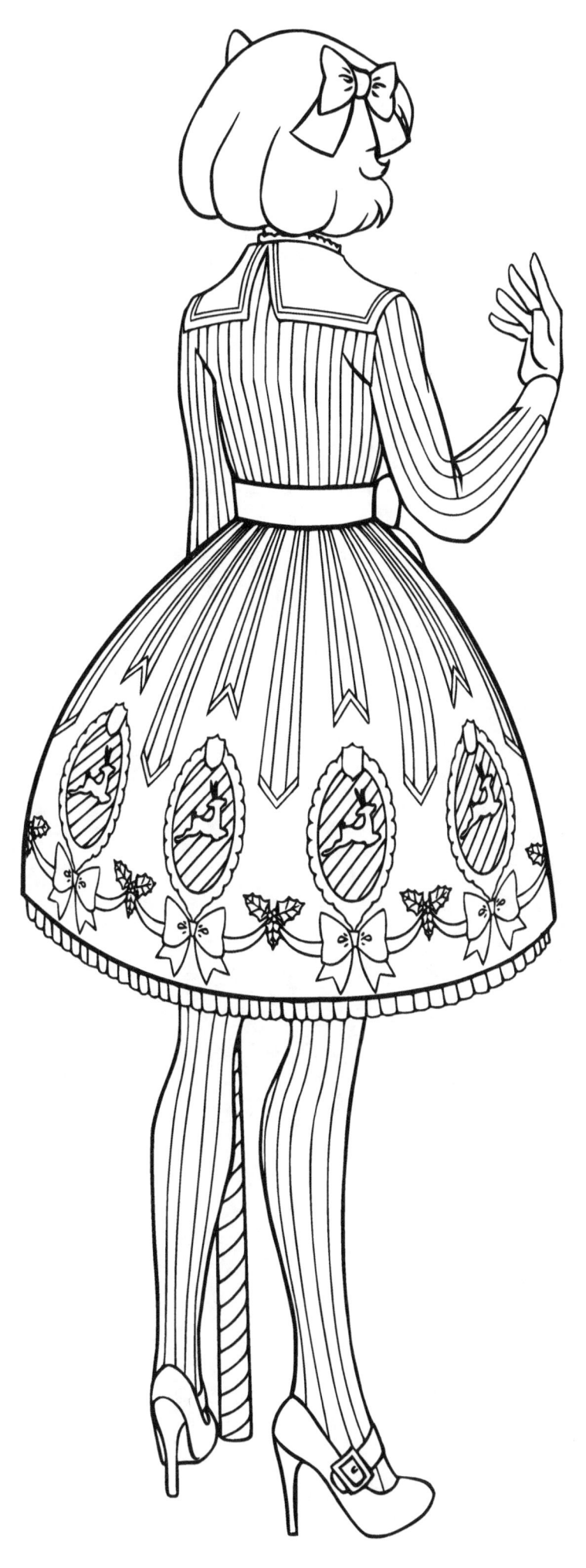

#12 "Peppermint"

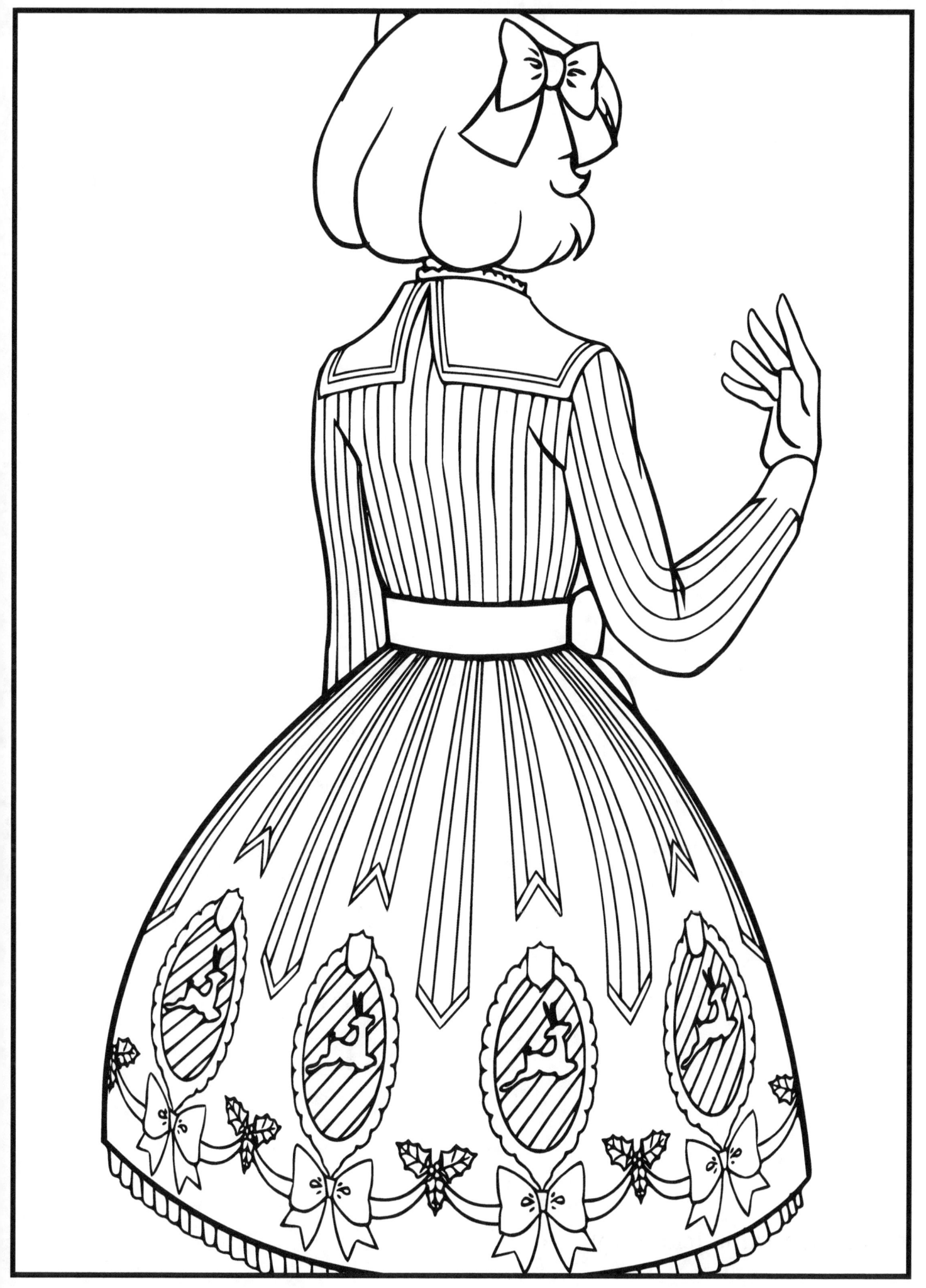

#12 "Peppermint" (close-up)

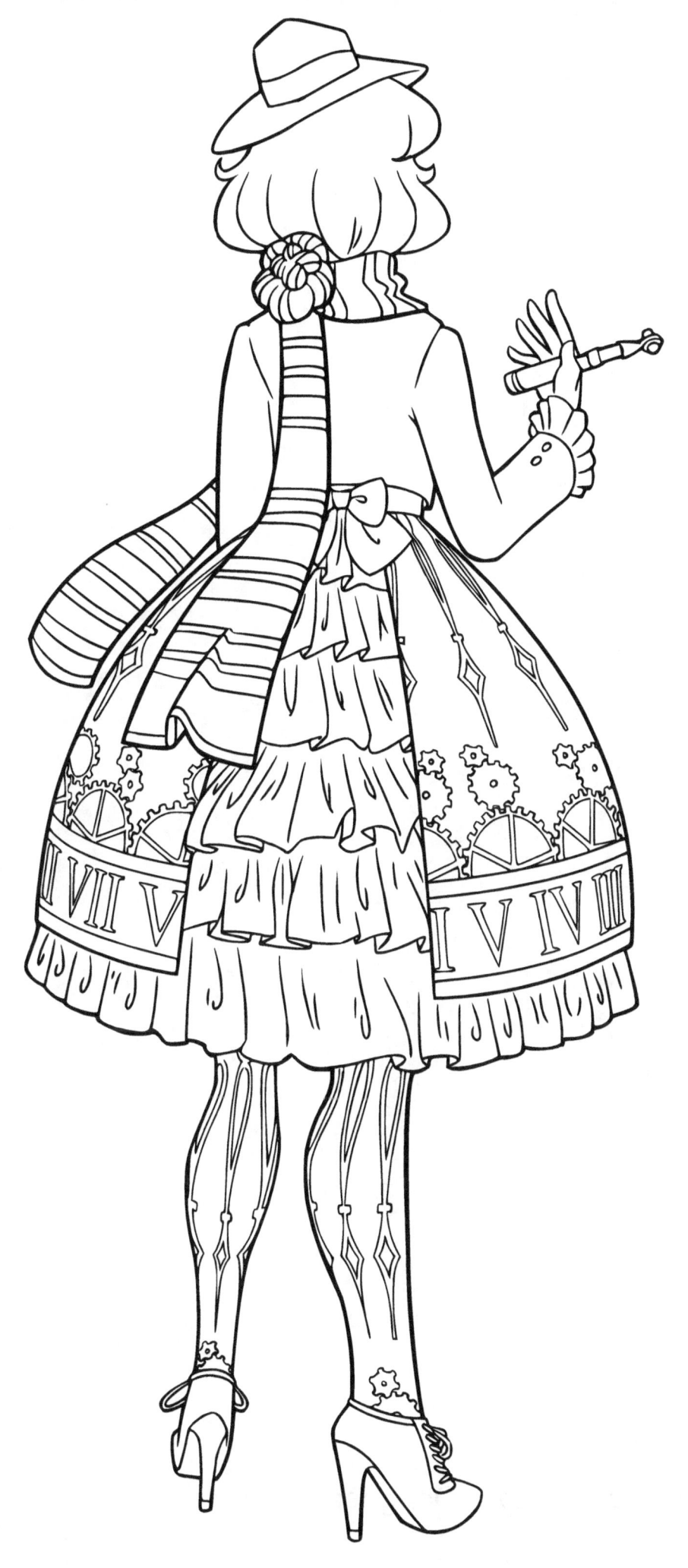

#13 "Tailored Apparel, Rococo Designed, Impeccably Styled"

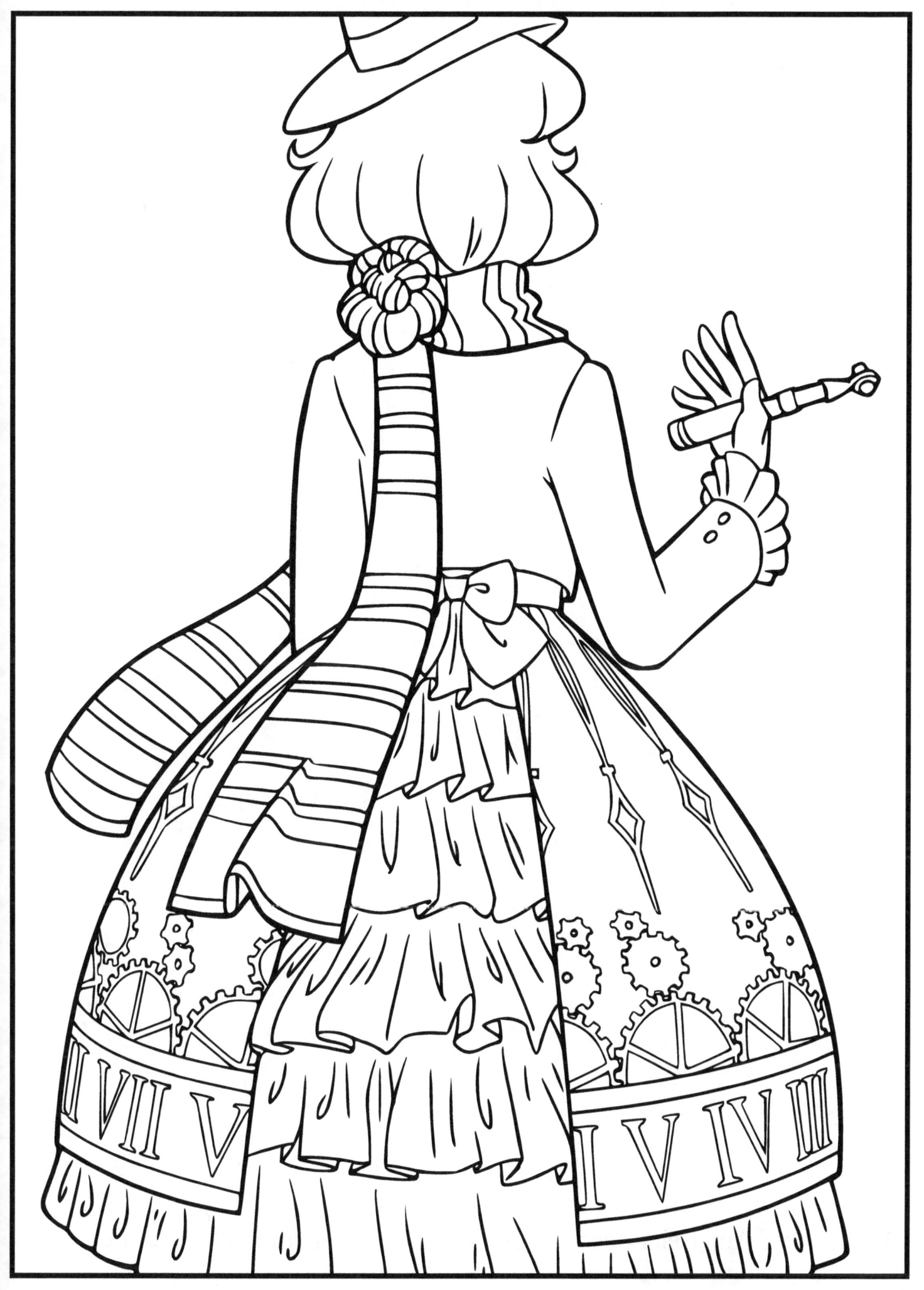

#13 "Tailored Apparel, Rococo Designed, Impeccably Styled" (close-up)

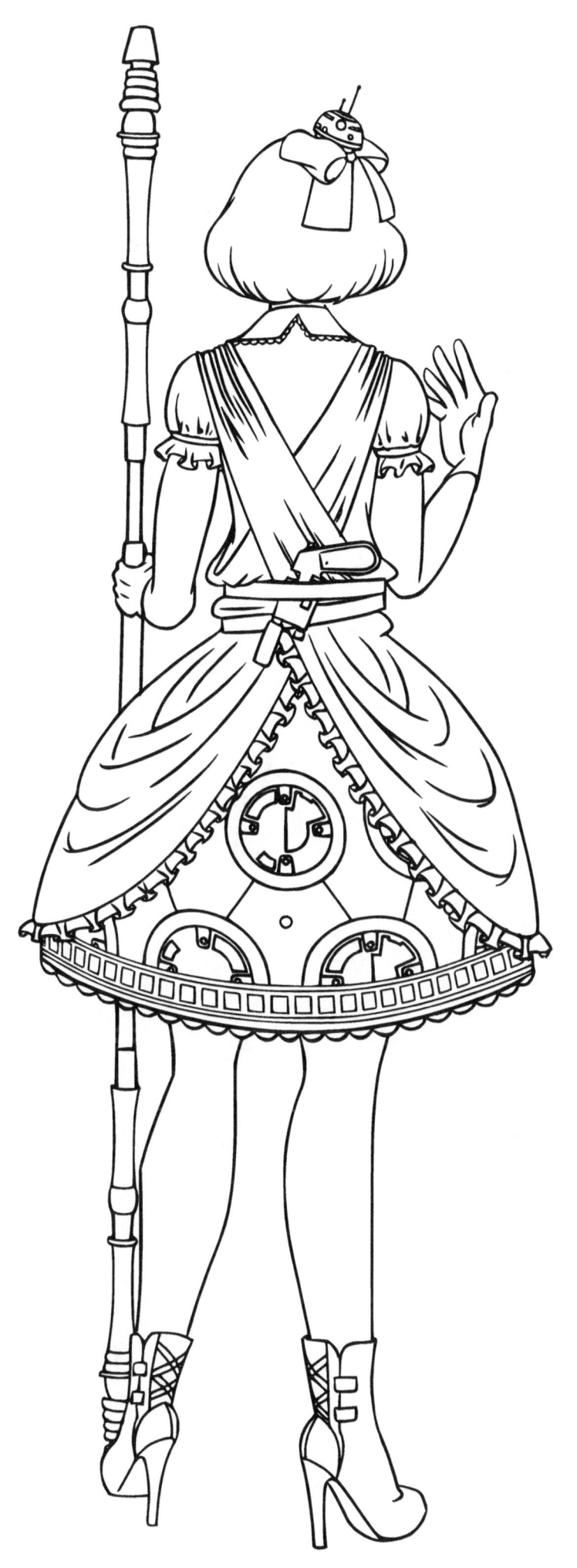

#14 "Scavenger"

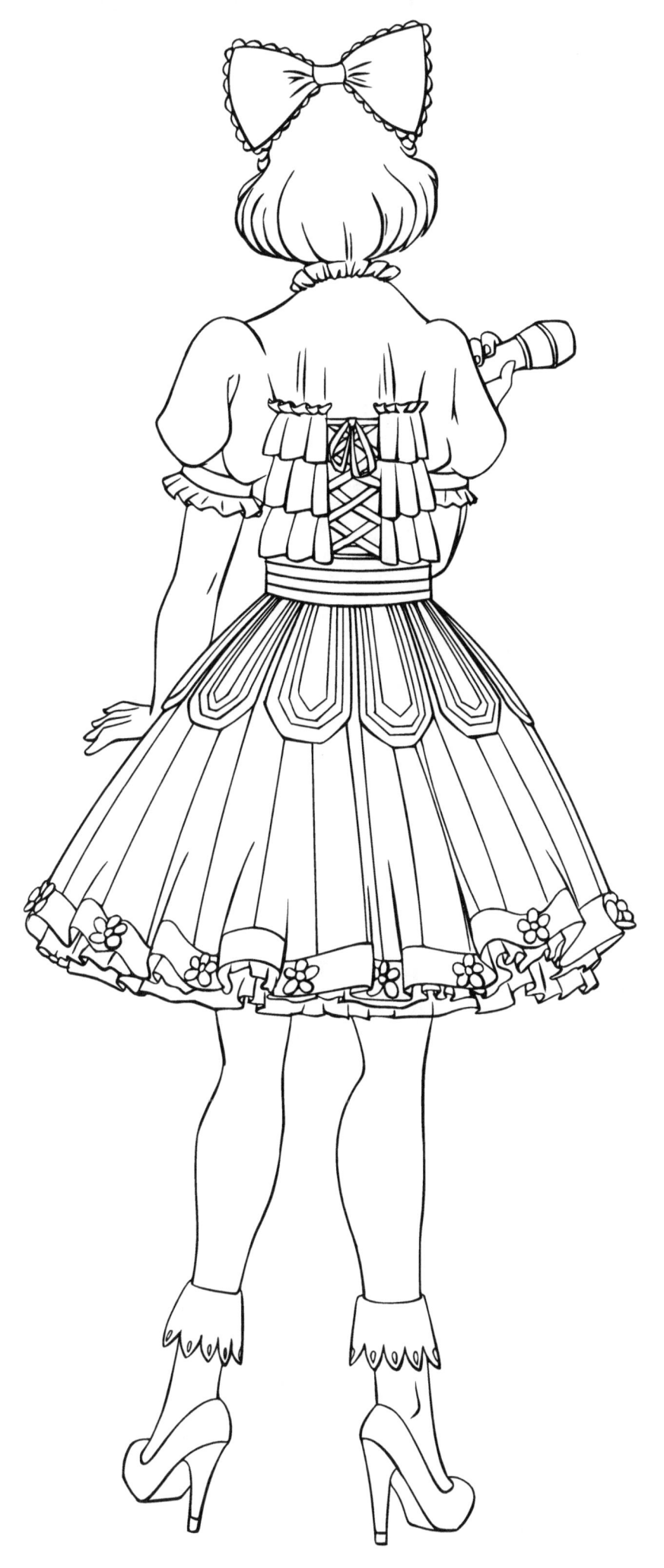

#15 "Kyary"

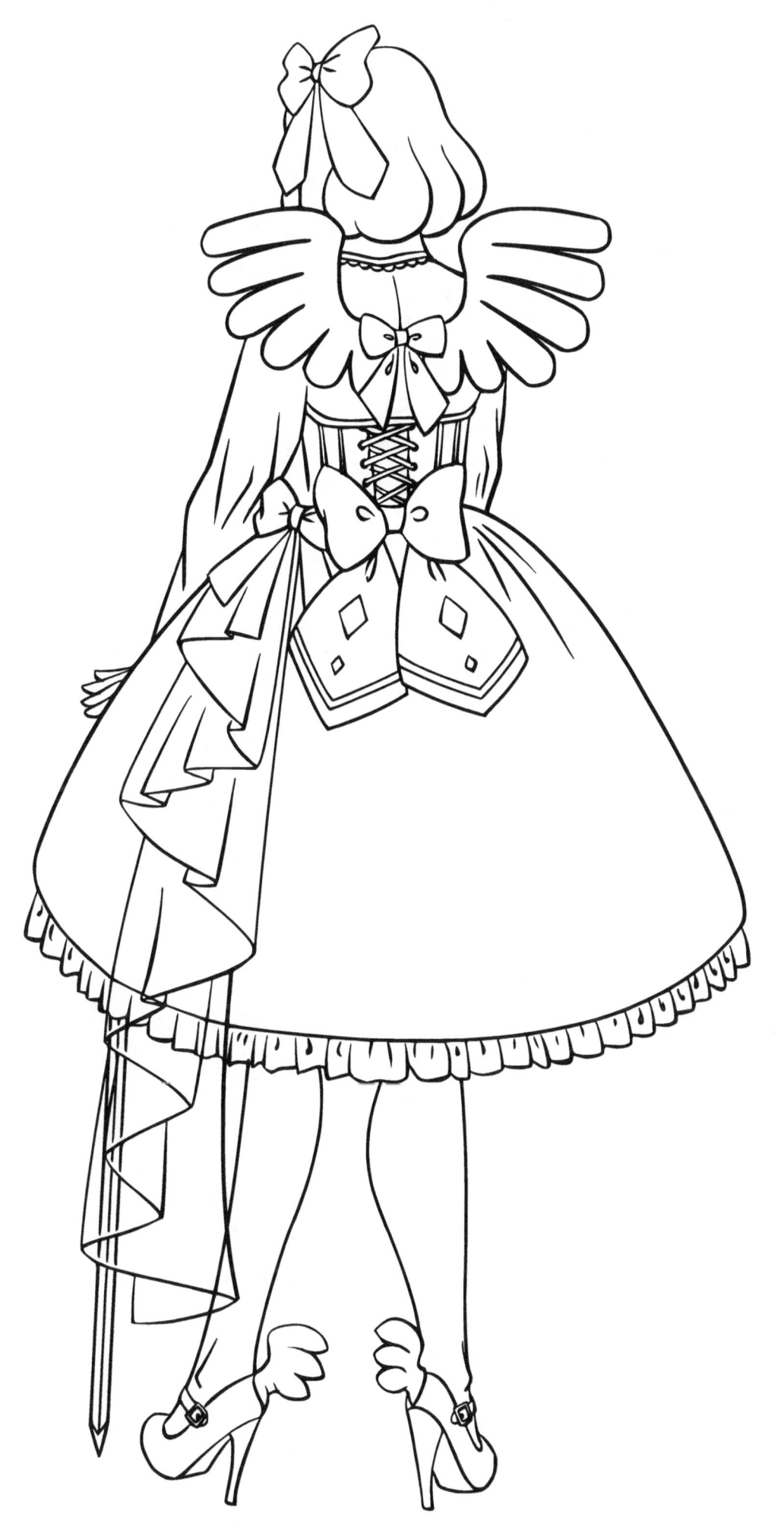

#16 "Tenshi"

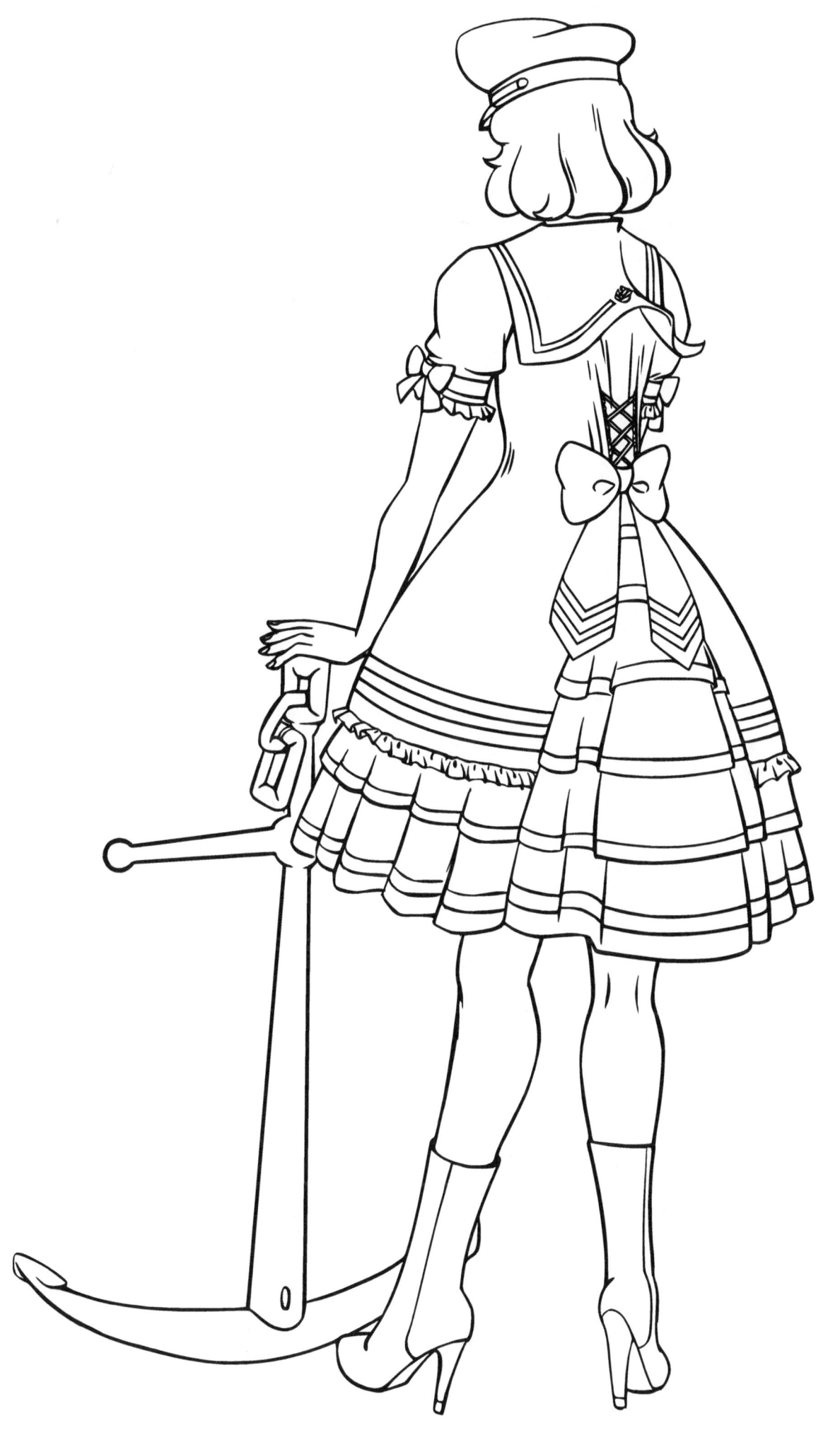

#17 "Sailor Lolita"

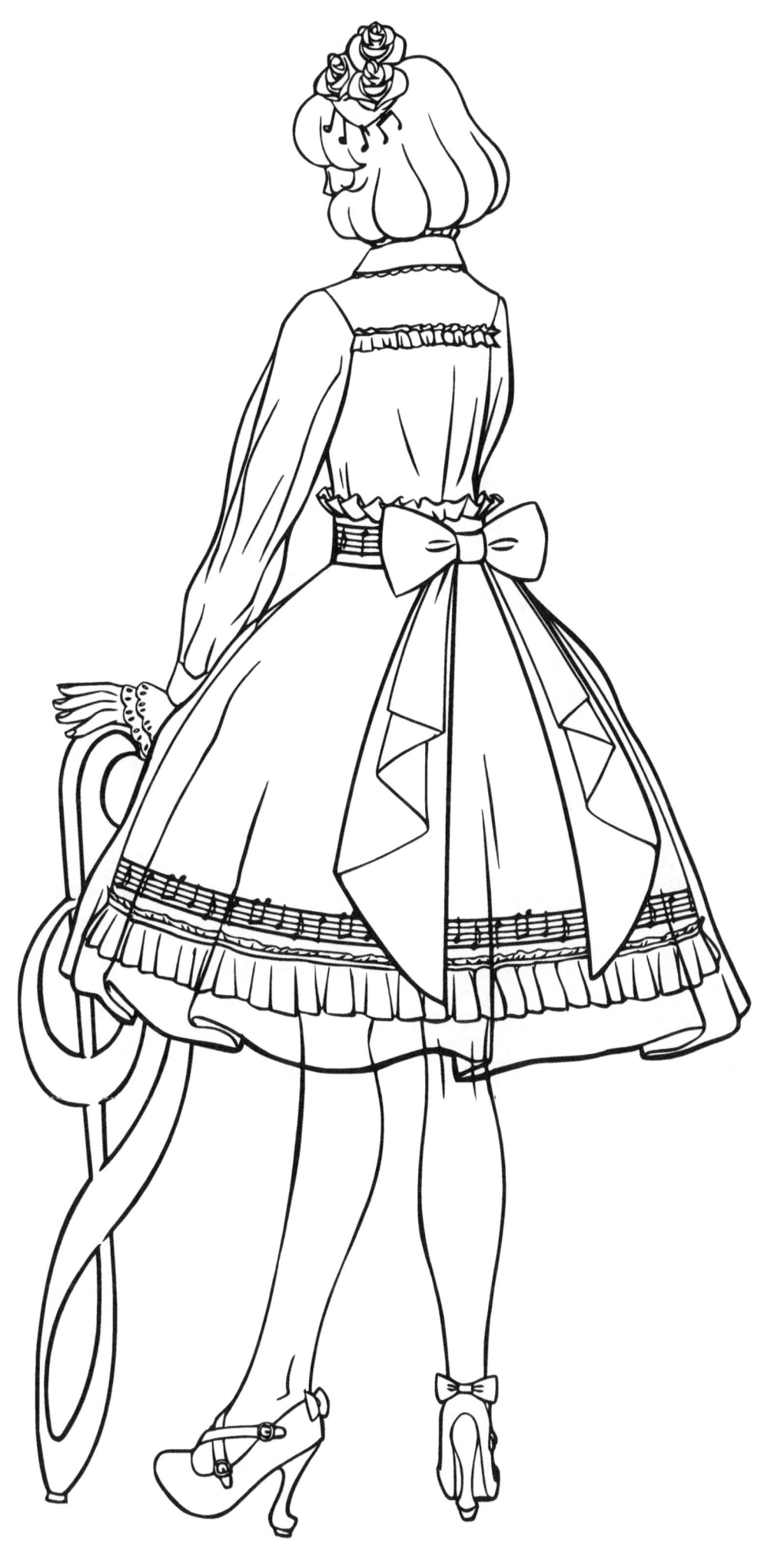

#18 "Musical Lolita"

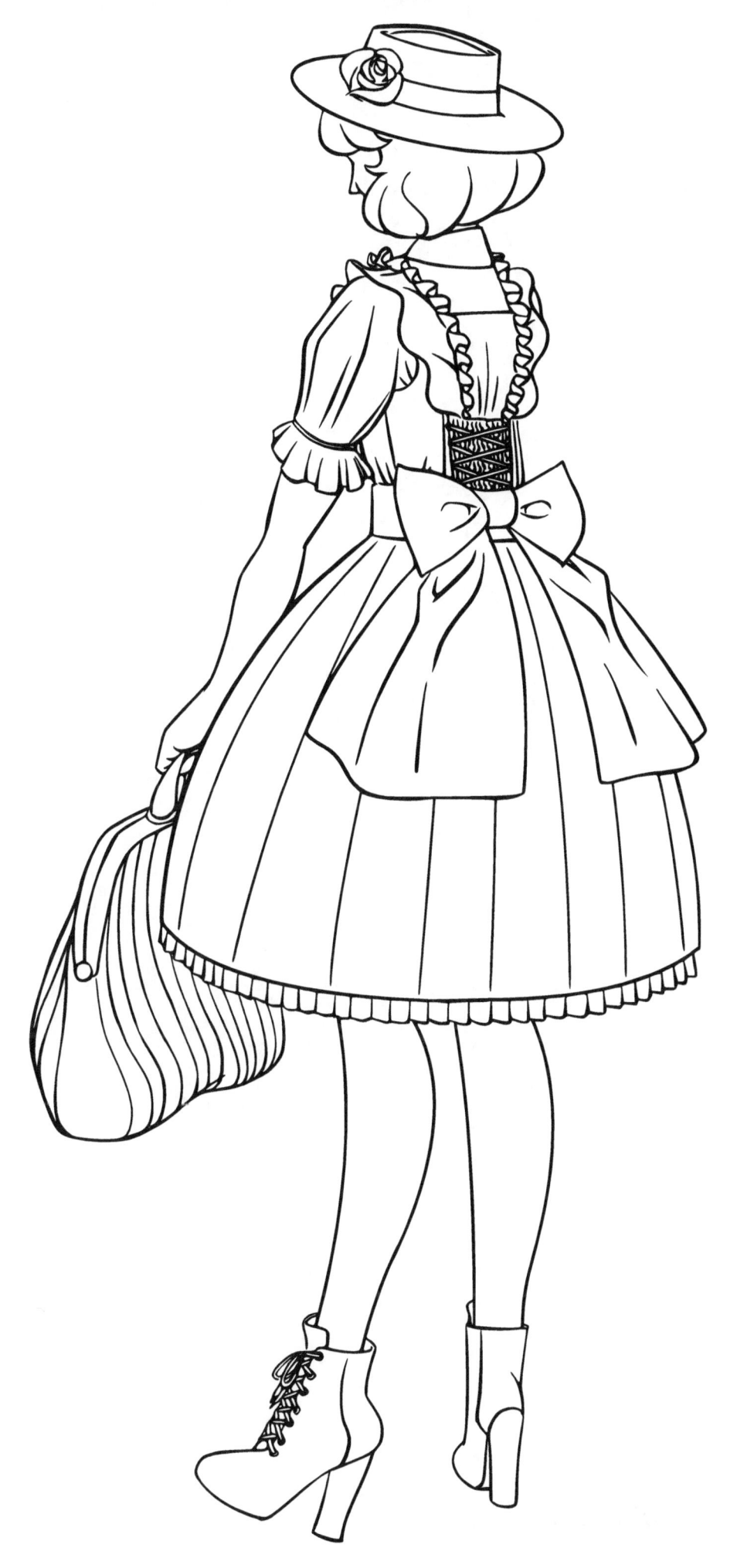

#19 "Miss Kamiko of Avonlea"

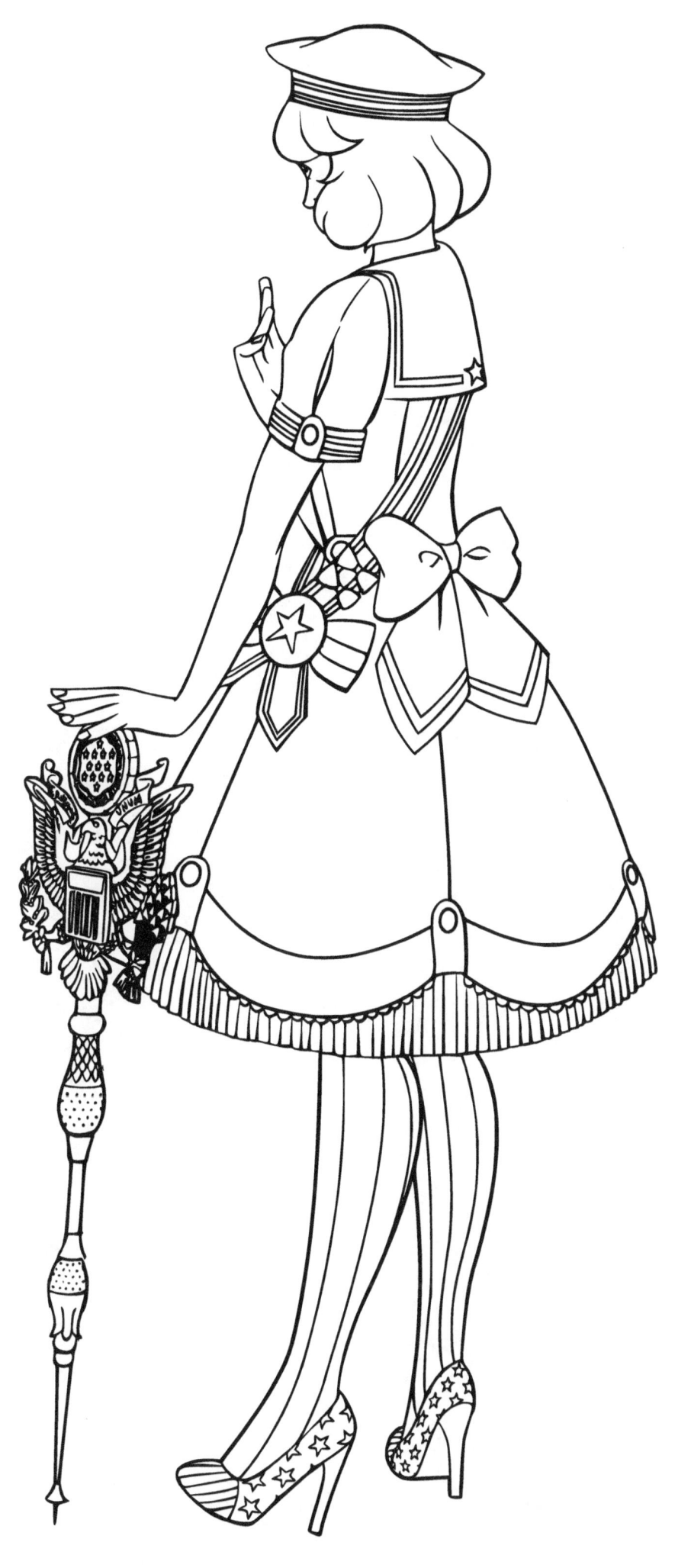

#20 "Captain Americatown"

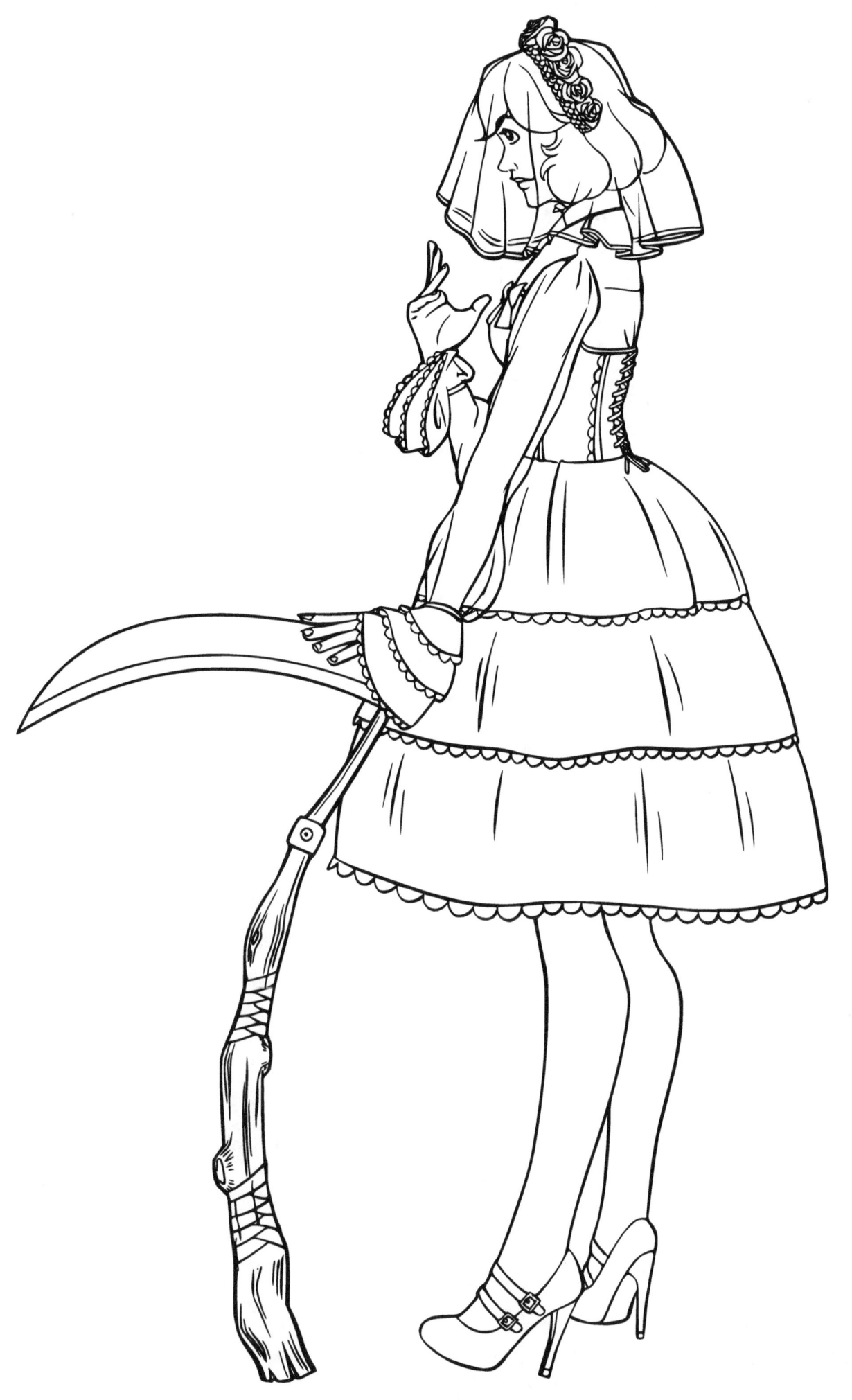

#21 "The Reaper"

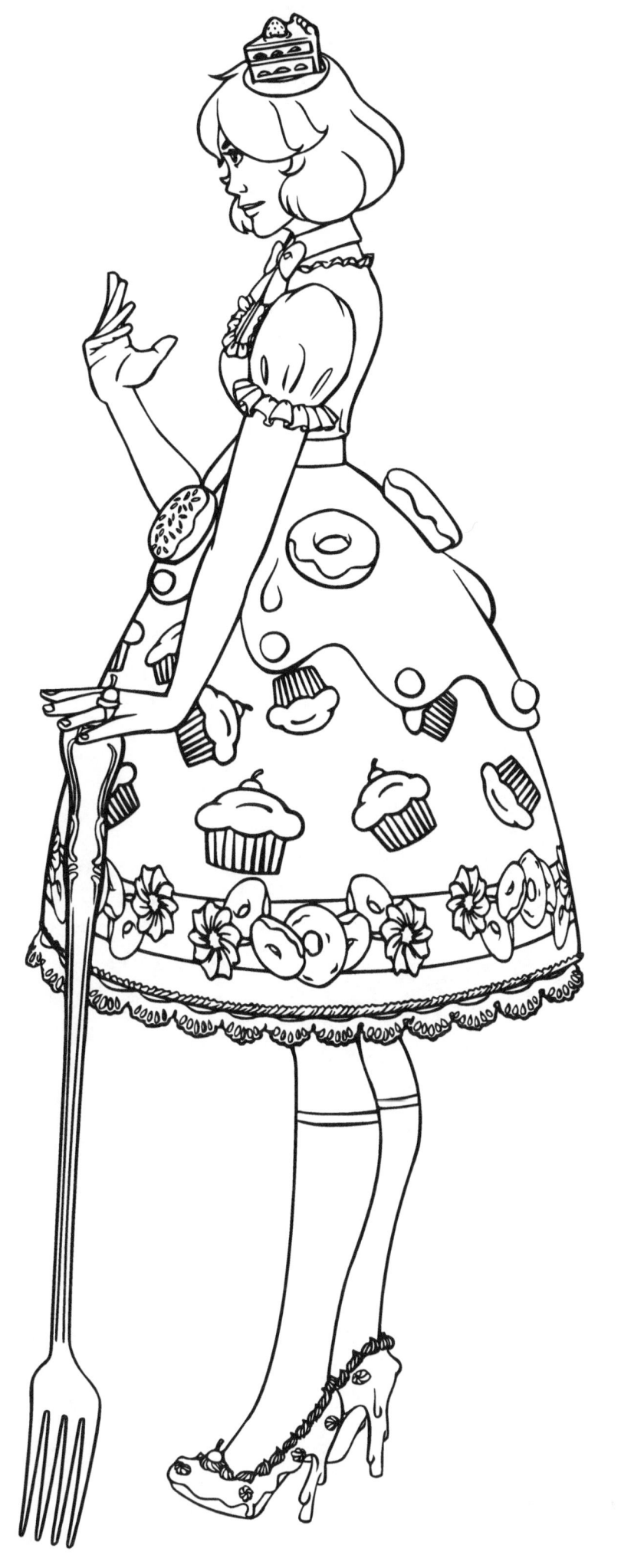

#22 "The Pastry Queen"

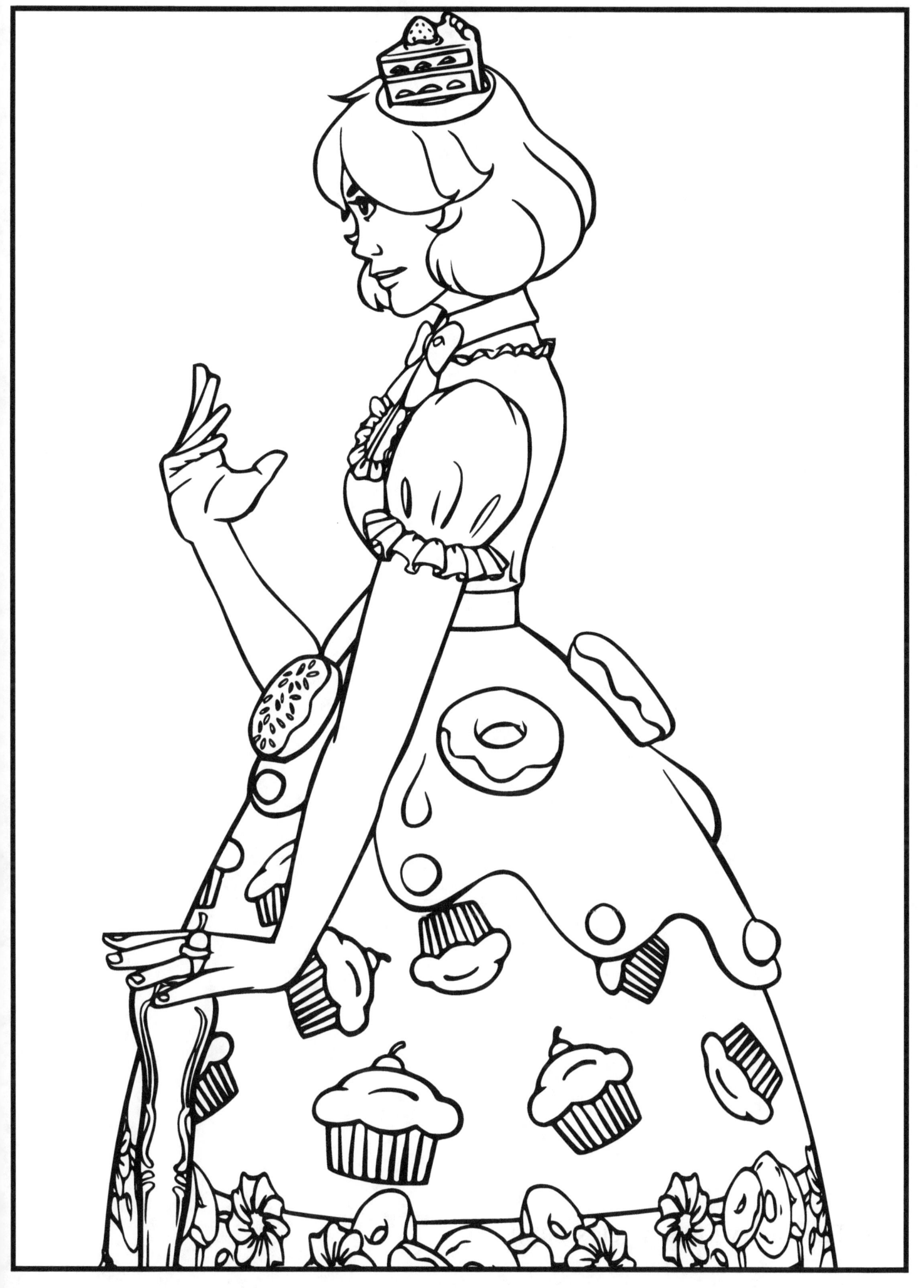

#22 "The Pastry Queen" (close-up)

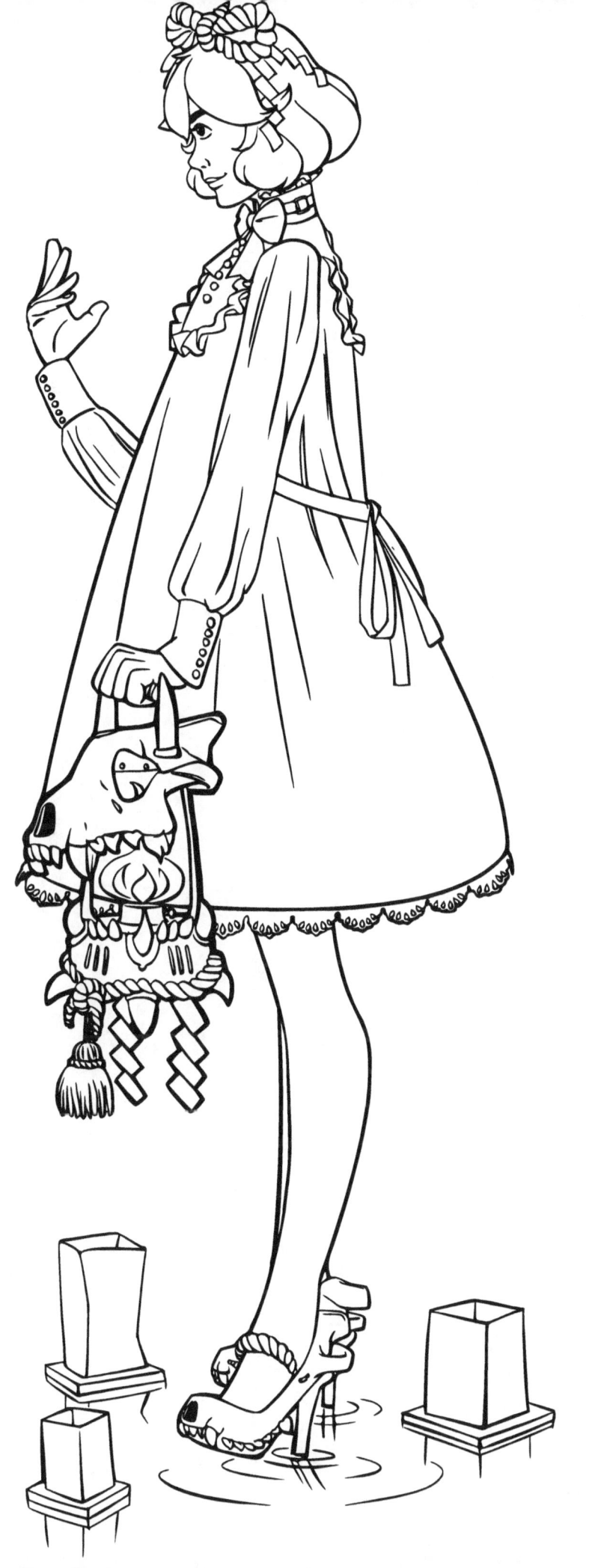

#23 "Holy Lanterns"

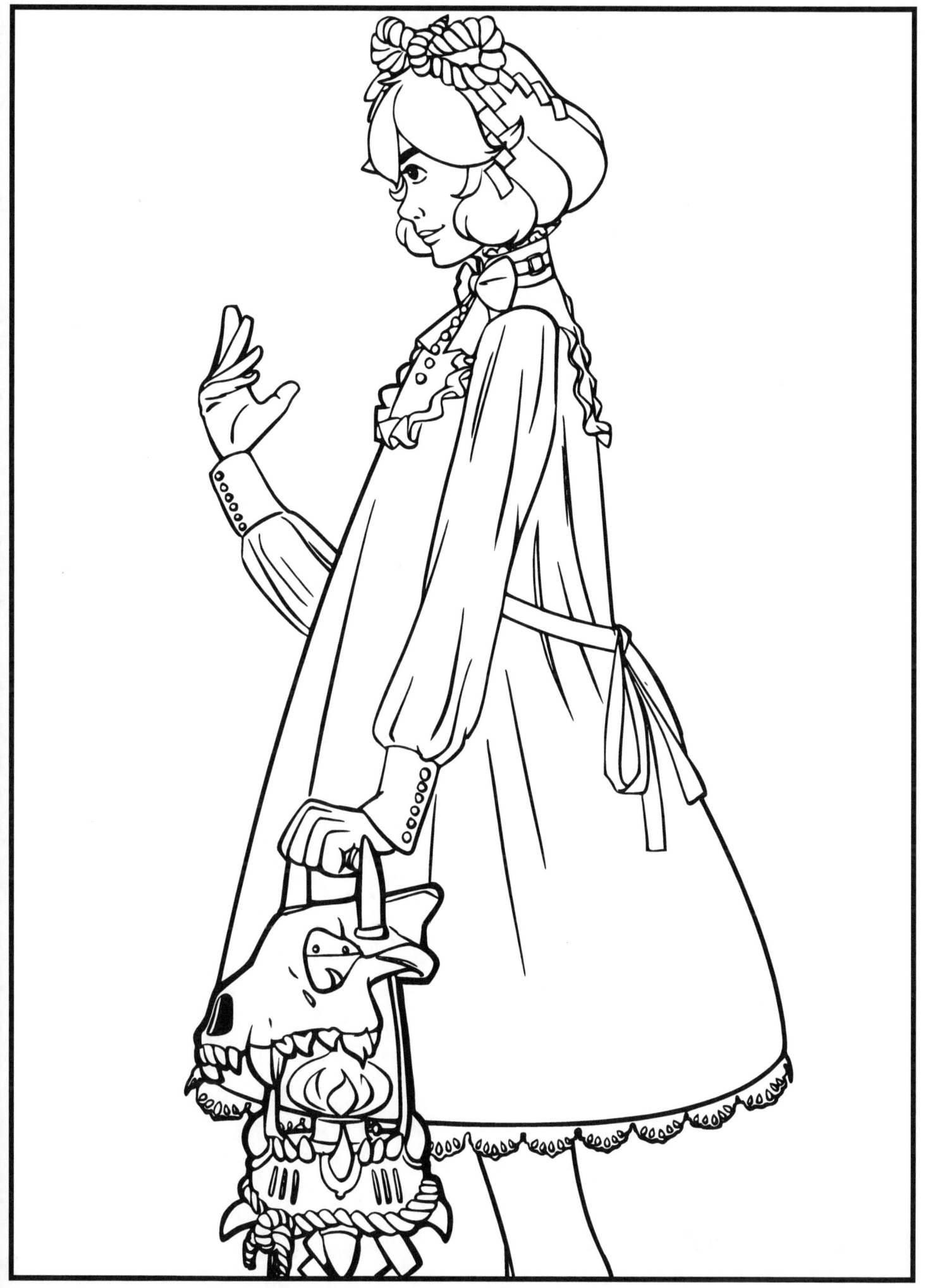

#23 "Holy Lanterns" (close-up)

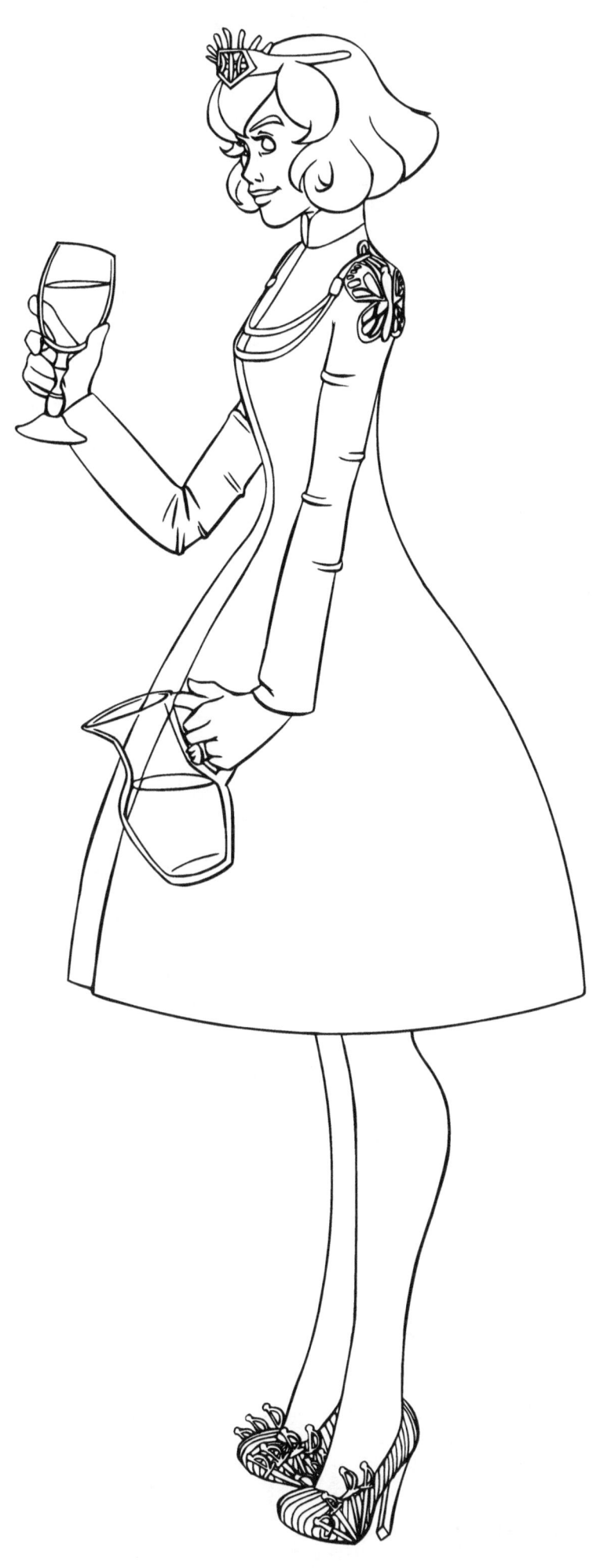

#24 "Shame. Shame. Shame."

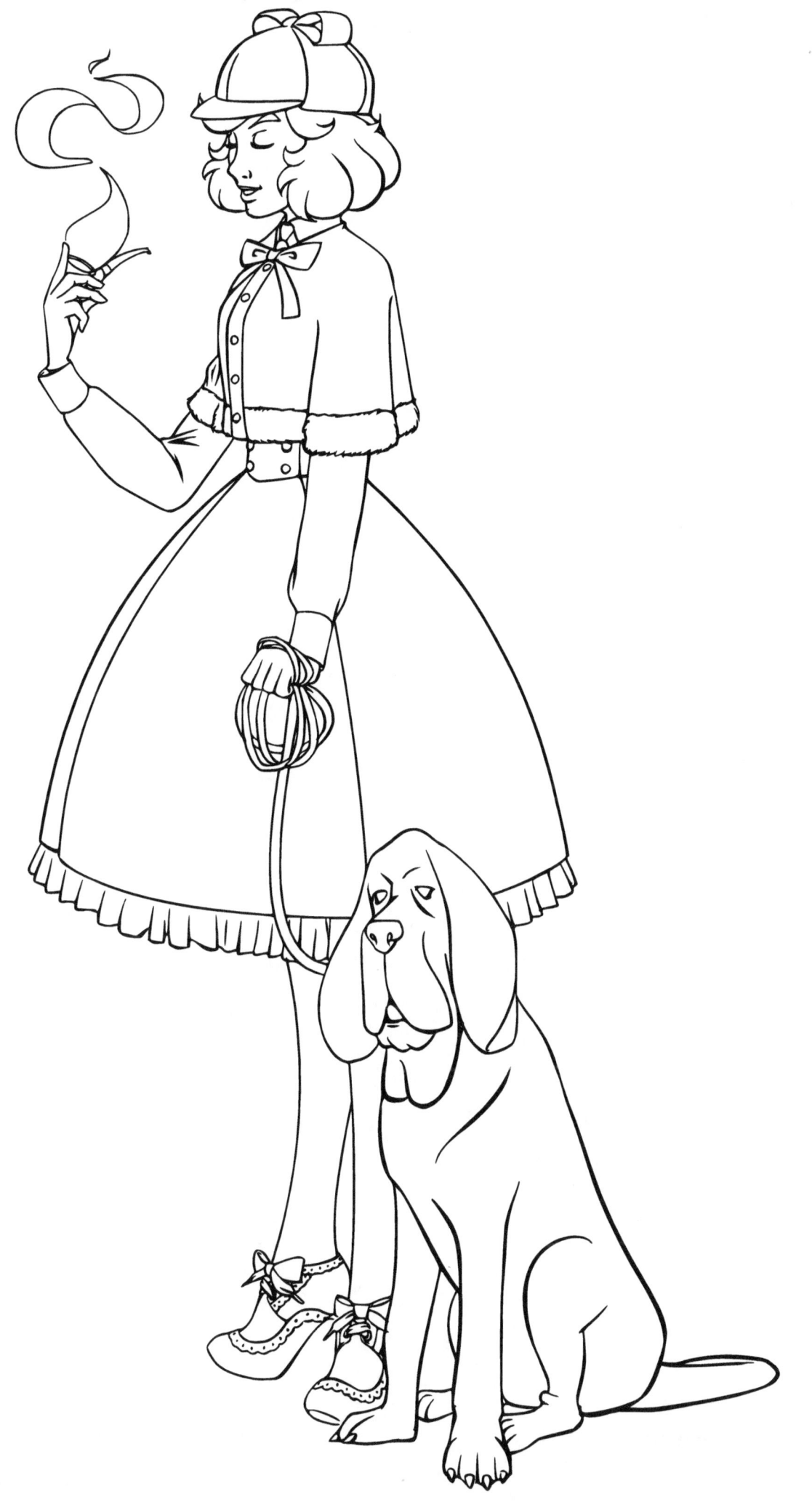

#25 "Deerstalker and Hound"

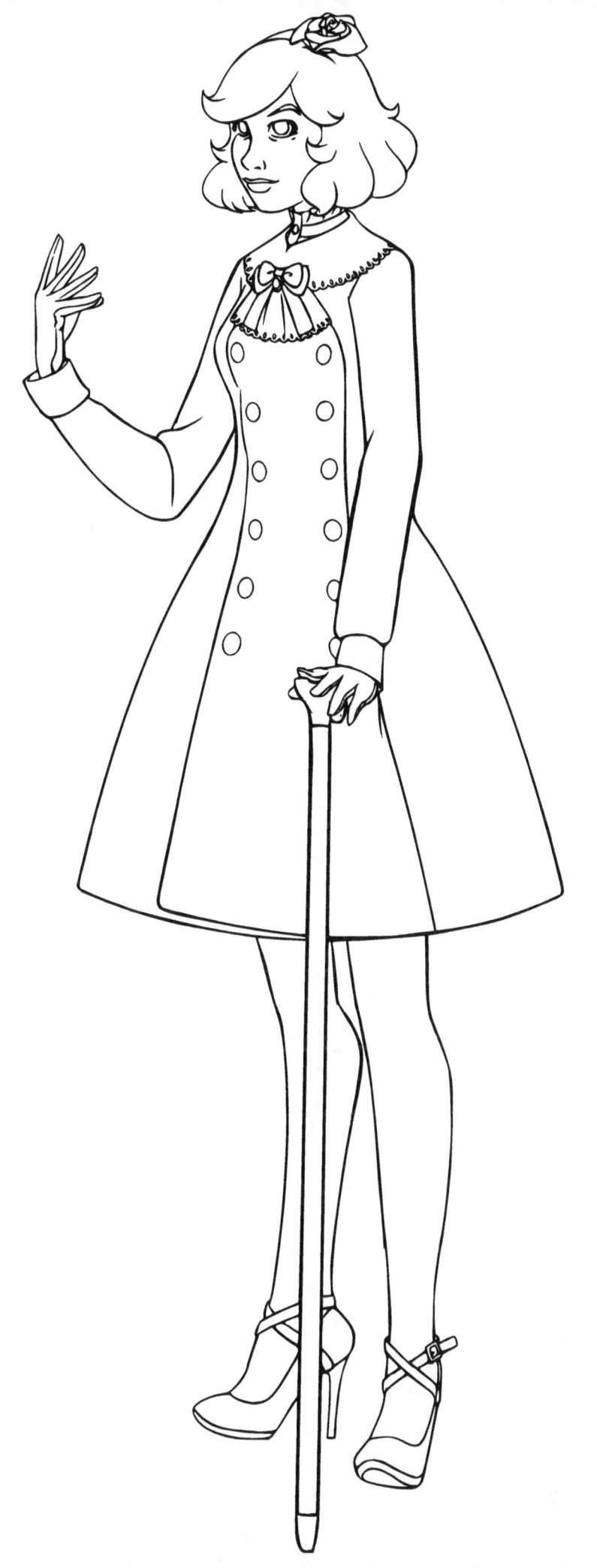

#26 "Academy Lolita"

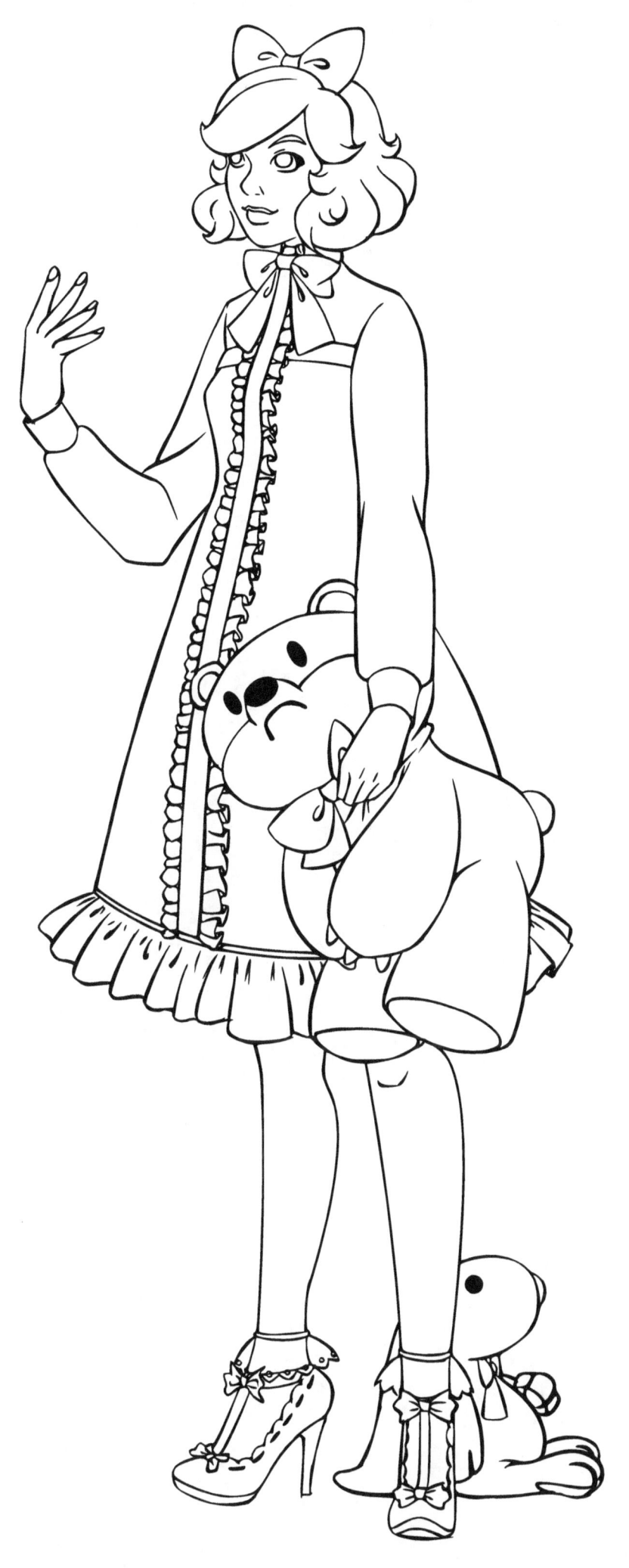

#27 "Lo. Lee. Ta."

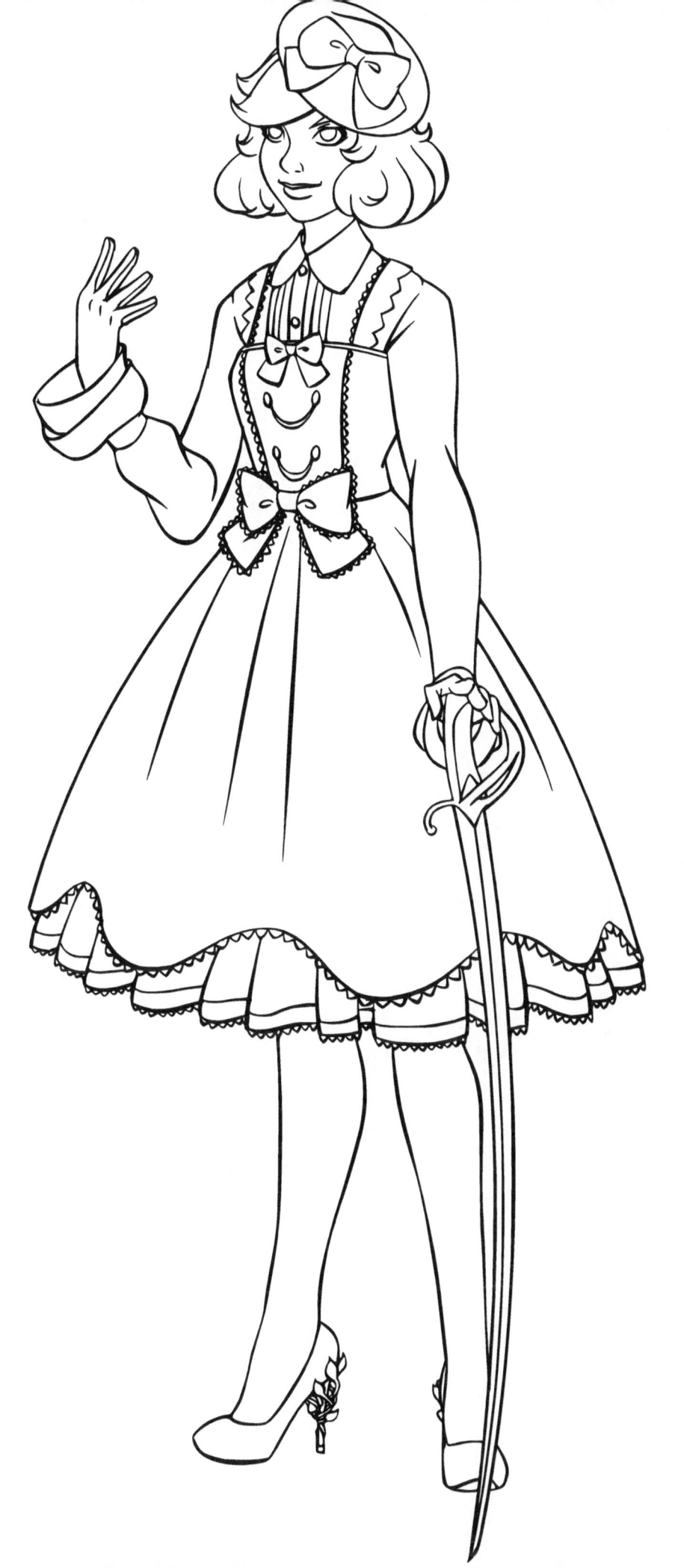

#28 "Legionnaire"

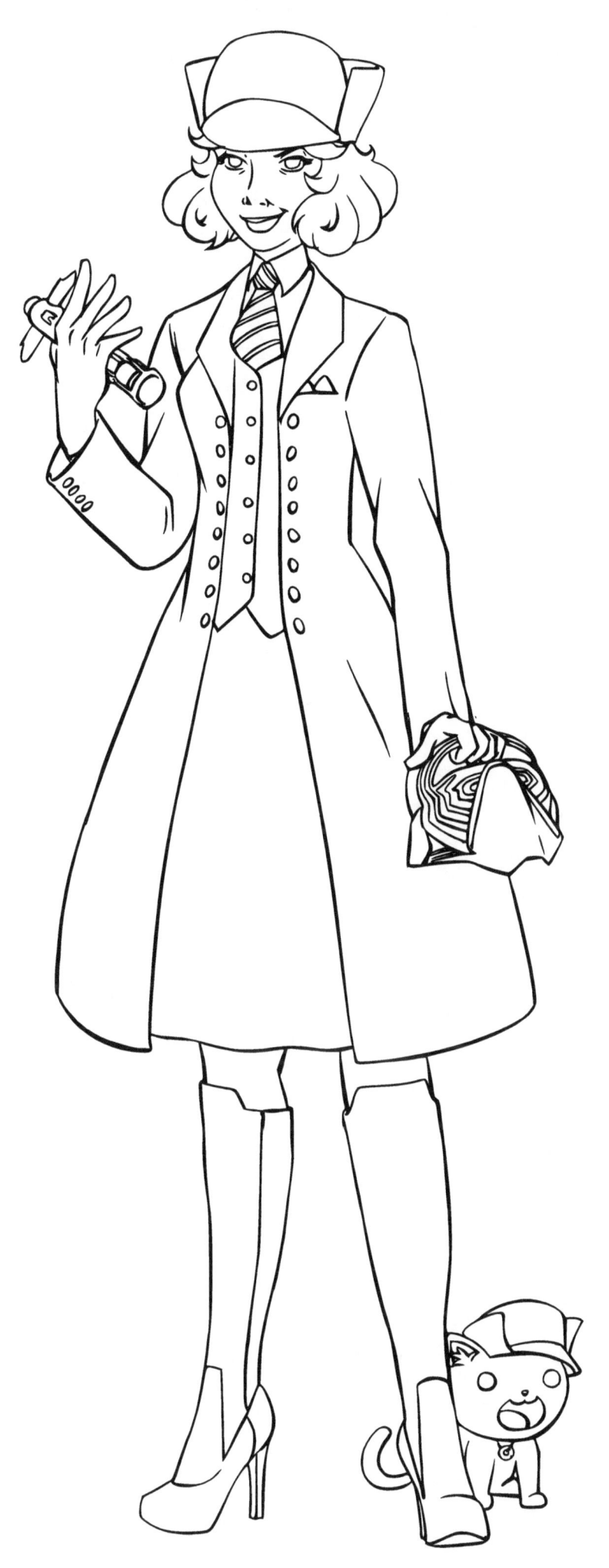

#29 "The General"

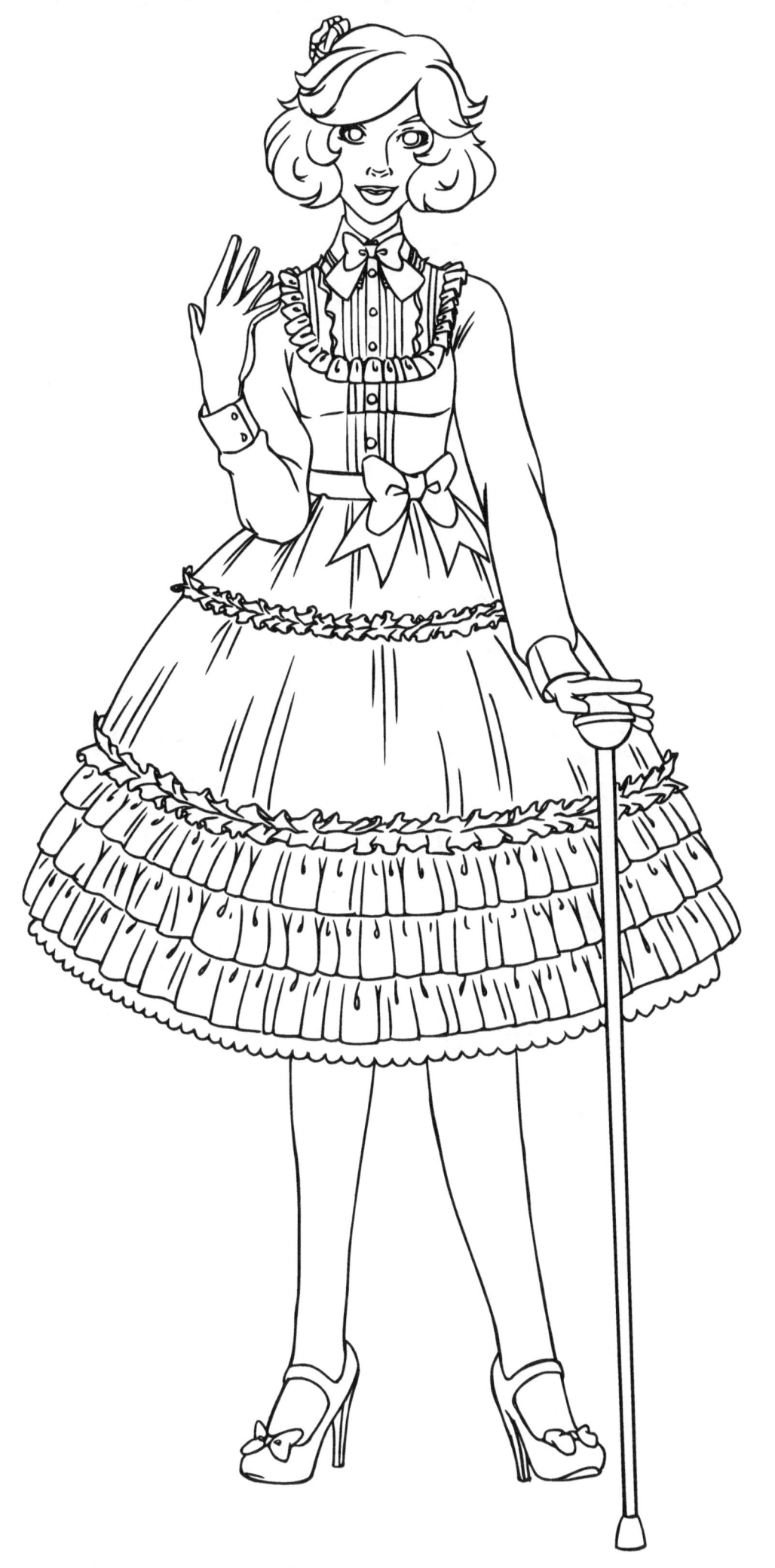

#30 "Sweet Lolita"

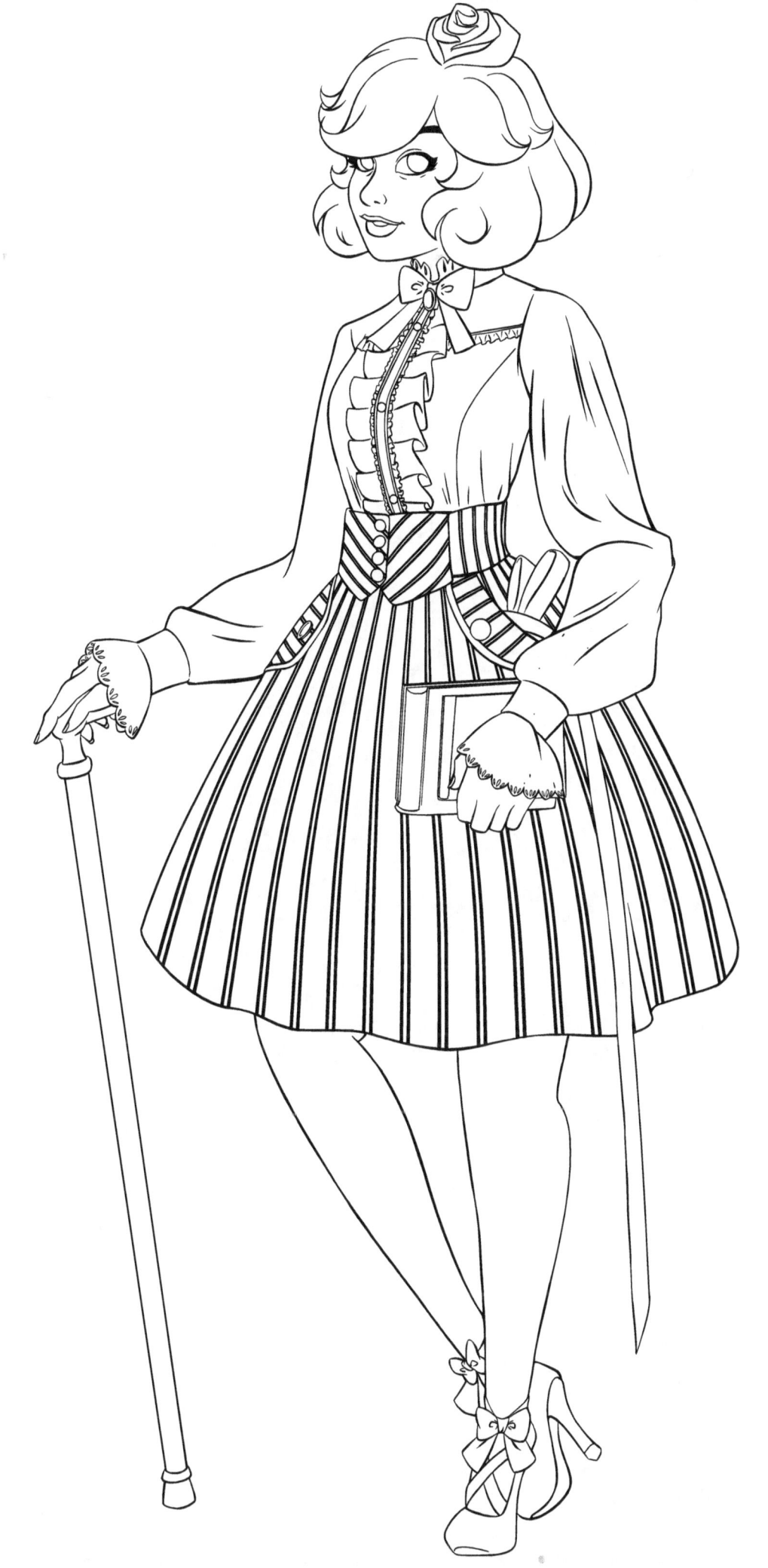

"Dear Kamiko (April 2016)"

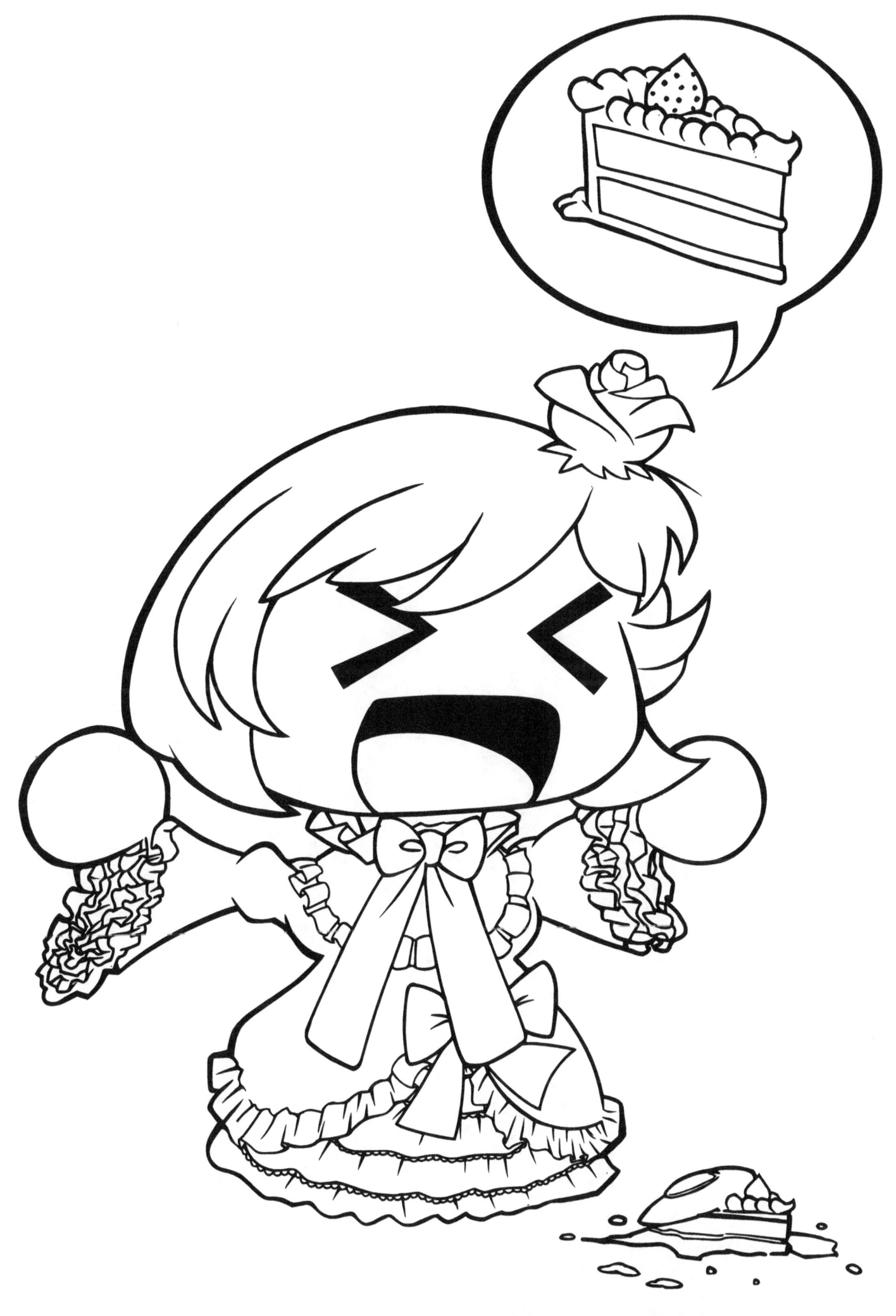

"Cake Malfunction"

Color Test Page

About the Author

Glenn Song is an illustrator, writer, and software engineer. During the day he makes video games such as Toodle's Toboggan (iOS, Android) and at night he illustrates and writes the webcomic series *This Mortal Coil*. He loves Japanese traditional and pop-culture where Lolita street fashion comes from.

Follow me on Social Media

Twitter/Instagram: @AlbinoGrimby

Facebook:
facebook.com/thismortalcoilcomic/

Support me on Patreon:
patreon.com/thismortalcoil

E-mail: kamiko@mortalcoilcomic.com

Visit **www.mortalcoilcomic.com** for more art and comics by Glenn Song

www.ingramcontent.com/pod-product-compliance
Lightning Source LLC
Chambersburg PA
CBHW080719190526
45169CB00006B/2439